foundation course

oils and acrylics

foundation course

oils and acrylics

Nick Tidnam

with Curtis Tappenden

First published in Great Britain in 2004 by Cassell Illustrated
a division of Octopus Publishing Group Ltd.
2–4 Heron Quays, London E14 4JP

Text and design © 2004 Octopus Publishing Group Ltd.
Illustrations © 2004 Nick Tidnam

Series development, editorial, design and layouts by
Essential Works Ltd.

Distributed in the United States of America by
Sterling Publishing Co., Inc.,
387 Park Avenue South, New York, NY 10016-8810

A CIP catalogue record for this book is available from
the British Library.

ISBN 1 184403 144 6

Printed in China

Contents

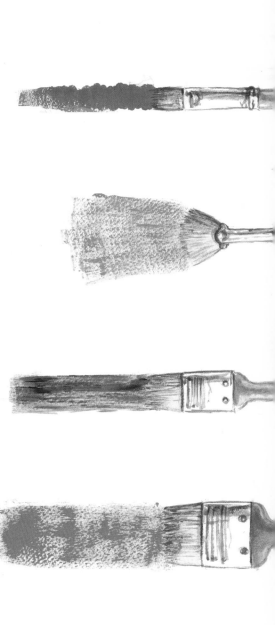

Introduction

Oil painting is the most richly intense form of image-making, and its jewel-like colours are as transparent as they are densely saturated. The development of oil paint as a versatile medium has been exciting and rewarding for the artists who have devoted themselves to it. Initially it was applied in a very prescribed manner, with thin glazes and smooth, imperceptible brushstrokes. But since the fifteenth century it has been used in a variety of broad-ranging techniques. These include the building of thick textured layers, the flowing of thin veils of translucent colour, and the free expression of marks through a diverse range of specialized brushes and tools.

Acrylic painting is both similar to oil painting and quite different. It certainly adapts itself easily to the techniques of oil, but then offers exciting new possibilities as a form of, among other things, watercolour. In short, it is probably the most flexible medium ever invented and if you are starting out, be alert to the great benefits it can offer your work.

If you are unsure of your abilities with paint and want to develop a personal visual language, then this book is for you. It offers a thorough and succinct guide to the various tools, materials and techniques available in both mediums.

There are exercises in creating textures and developing technique to help you gain confidence in handling paint, juxtaposing colour and reproducing form. We also look at the essential elements that need to be understood when creating pictures, such as tone, composition and rhythm. Paintings by the great masters, both past and present, are analyzed to inform technique and inspire new directions.

Finally, there are step-by-step 'Masterclasses', which examine the creation of several paintings from initial sketches to finished work. Dare to release the lid on these two truly exquisite mediums, enjoy their similarities and differences, and the joy of artistic expression: happy painting!

A history of oil painting

A European invention

The emergence of oil paint in the fifteenth century fulfilled an overwhelming need for a more flexible paint than egg tempera. Artists such as the Dutchman, Jan van Eyck (c.1390–1441), had struggled to work with its rapid drying times, frequent surface cracking, and the inability to be able to blend colours on the support. This led to experimentation with gum arabic, waxes and nut oils. Whether or not Van Eyck was the sole inventor of oil paint is open to debate – it is quite possible that resins and oils were being added to pigments from as early on as the eighth century. However, he has been credited as the man who developed a whole new approach, wherein an earthy base preparation known as an underpainting was followed by the application of richly coloured, transparent oil layers known as glazes. Significantly, these could be changed and corrected without deadening their original luminosity.

Spreading the new medium abroad

Word travelled fast; a follower of Van Eyck, Antonello da Messina (1430–1479), took the new practice to Venice, where Giovanni Bellini (1430–1516) was quick to pick up on the glowing technique and exploit it with his own inimitable flamboyance. A calmer use of oil was revealed in the more intimate works of the Florentine, Raphael Santi (1483–1520), who kept his hues generally paler and far purer; his skin tones had a white transparency, achieved with the use of walnut, not linseed oil. Bellini's most famous pupil, Titian (1488–1576) developed oil as the medium of freer expression using loose, fluid brushstrokes to describe contorting, classical figures on a broader scale. By the beginning of the sixteenth century, oil paint was the principal medium used by contemporary painters.

The Flemish painter Jan van Eyck, one of the pioneers of oil painting, fully explored its translucent qualities in Man In A Red Turban. *It is not known whether this was a self-portrait or a portrait of his father-in-law.*

Darker developments into Baroque

An overall mid-tone applied to the painting surface gave artists a means by which they could assess their darker and lighter tones. Shadows were made with thin, dark glazes, and whites were mixed more heavily into stronger colours to provide dramatic highlights. Caravaggio (1573–1610) made full use of this method to attain astoundingly high levels of realism and three-dimensionality in his dramatically lit figures – a technique known as 'chiaroscuro'. Peter Paul Rubens (1577–1640) also used tonal contrasts, but in a more inventive way. He washed thin greys onto white grounds, then marked out his compositions with strokes of rich golden yellow, before finally darkening the picture down with cooler, semi-opaque glazes, allowing the yellow to show through, thus permeating the scene with an overall source of warm light. Velazquez (1599–1660) derived influence from both painters, the outcome of which was a sensitive, tonal handling of his subjects using an exciting variation of brushmarks to achieve a sense of movement and drama. Rembrandt van Rijn (1606–69), used the same technique, but often grounded his paintings with a layer of red clay as well as the grey base. He certainly enjoyed the physical qualities of oil, sculpting the final detail coats with stiff, opaque strokes of lead white. This technique proved particularly successful in his later self-portraits.

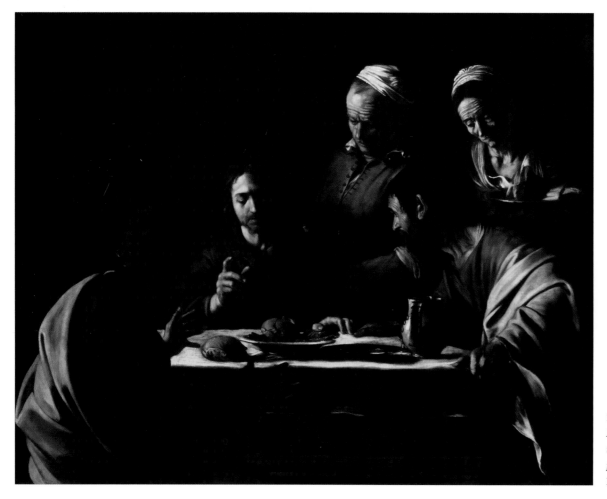

The Italian painter Michelangelo Merisi da Caravaggio took realism to new heights with his use of oil paint in images such as Supper At Emmaus *from 1606.*

Eighteenth-century experimentation

With an increasing understanding of how to use oil paint, layering became a more common practice in the eighteenth century, and some artists experimented with adding mediums and other materials to their oil paints. The renowned British horse painter George Stubbs (1724–1806), used drying oils to quicken his process and Sir Joshua Reynolds (1723–92), concocted new recipes with resins and bitumen. However, these early attempts to modify the qualities of oil paint were not always entirely successful: unfortunately the present-day condition of some of these works shows them to be less stable where non-traditional materials have been added.

Demand for ready-to-use oil paints at this time created a new service industry of artists' 'colourmen', who prepared and filled skin bladders with coloured formulations. This interesting development is often forgotten, as the colourmen disappeared as quickly as they had arrived once paint manufacture became an industrial process. At the time however, their business was an important one, as it was a cue for the emerging topographical painters such as John Constable (1776–1837) and William Turner (1775–1851), to work directly onto panels at a scene, finishing a painting in one sitting (*alla prima*) with brisk, fluid handling of the medium.

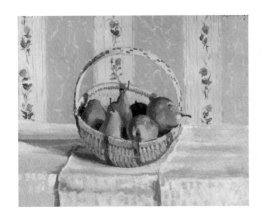

Camille Pissarro, the French Impressionist began to forge a new direction for oil painting in works such as Still Life Pears In A Round Basket *of 1872.*

Impressions of the nineteenth century

Turner may well have set the trend toward *plein air* painting, enticing outside such fellow pioneers as the French Impressionists. They happily left the confines of the studio to explore the effects of broken colour and refracted light on scenery through various seasons and times of the day. Colour theories and the further development of new pigments forced a sea-change in painting practice, with many of the traditional methods being shelved in favour of a freer, direct approach. Early exponents such as Claude Monet (1840–1926) and Camille Pissarro (1830–1903) produced intricate compositions with the strokes actually playing an integral part in the meaning of the picture. The discarding of glazes in favour of rich saturations of impasto brought a new life and immediate vitality to works, and techniques diversified again as a result. Others who took their pioneering lead include Vincent van Gogh (1853–1890), Paul Gauguin (1848–1903), Georges Braque (1882–1963), Pablo Picasso (1881–1973), and later in Germany the Expressionists, Emil Nolde (1867–1956), Franz Marc (1880–1916) and Max Beckman (1884–1950).

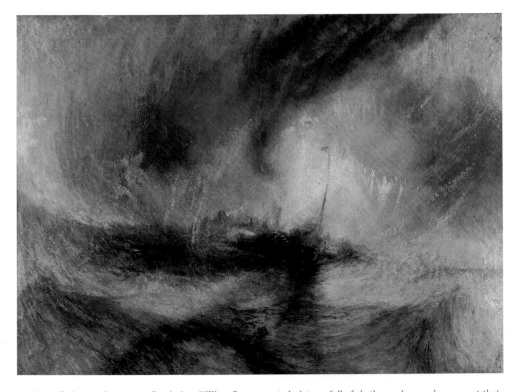

A giant of nineteenth-century oil painting, William Turner created pictures full of rhythm and sensual movement that, while ostensibly figurative, prefigured abstraction by several decades. This painting from 1842, Snowstorm: Steamboat Off A Harbour's Mouth, *is a good example.*

The twentieth century and beyond

A revival of traditional techniques at this time was predictable perhaps, but emerged from a surprising source: the peculiarly idiosyncratic surrealist, Salvador Dali (1904–1989). Influenced by the absurdism of Dada and the new theories of psychoanalysis, he blended his symbolic forms into each other as interpretations of a strange and erotic, unconscious dream world.

Another giant of the age, Pablo Picasso (1881–1973) redefined the language of modern painting by showing several different aspects of a subject simultaneously. Cubism, as this was known, still used traditional painting methods; his early 'Rose Period' shows this most clearly. Although his work became powerful and brutal, his handling of oil hardly changed throughout his long and innovative career. With such a number of concurrent styles in existence, many artists began to believe that there was no correct way to paint. The twentieth century emerged as an era of widely diverse painting movements worldwide. The Abstract Expressionists redefined technique in America through the 'action paintings' of their leading figure, Jackson Pollock (1912–1956). He threw paint at the canvas and allowed it to drip in a haphazard yet controlled way. The interest in pop culture across the globe in the 1950s and 1960s heralded the arrival of bright young things such as Jasper Johns (b.1930), Peter Blake (b.1932), Roy Lichtenstein (1923–1997) and David Hockney (b.1937). They began with oil, using it as a flat, graphic medium, but soon converted to the more suitable plastic-based acrylic. Countering this trend, a return to figurative painting swept Europe. The Frenchman, Balthus (1908–2001), built his human mysteries employing layers of a controlled limited palette. Livelier mark-making is apparent in the oil-encrusted works by Leon Kossoff (b. 1926), Frank Auerbach (b. 1931), and Lucian Freud (b. 1922). As members of the London School, they reveal an enjoyment of paint almost entirely for its own sake, and Howard Hodgkin (b. 1932) represents his memories in sensational swirls of intense oil colour.

Despite the advancing technology in a wealth of alternative paint products, oil is still a popular and respected medium. No other paint type has its richly saturated quality and permanence – its place in the future is secure.

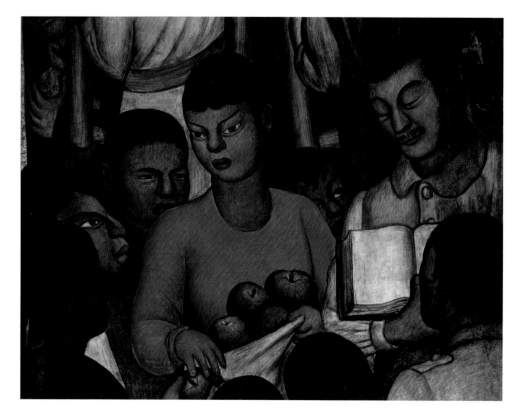

Diego Rivera made good use of the new medium of acrylic paint to create polemical, fresco-like works such as Fruits Of The Earth *(detail). Painted in 1932, this heralded a new age in image-making.*

A history of acrylic painting

Plastic Revolution!

The origins of acrylic resins can be traced to the turn of the twentieth century in Germany, but their development as a binder for pigment was completed in America at the beginning of the 1920s, where it was discovered that resins could be dissolved into organic solvents. Architects had long been searching for a colorant that would remain stable under hot exterior conditions, and car manufacturers needed a tough, resistant coating that could withstand wear. However, it was in the field of mural painting that commercial production began in the 1940s, to supply the need for atmospherically durable paints. Pioneers of the plastic revolution had just emerged from their own revolution in Mexico, and David Alfaro Siqueiros (1896–1974), Diego Rivera (1886–1957) and Jose Clemente Orozco (1883–1949) created bright, permanent, fresco-style depictions in celebration of the new Mexican order.

An oil substitute

Artists who first used acrylic did so by applying the 400-year-old techniques of underpainting and glazing to the new medium. However, the beauty of acrylic is its versatility, being an able substitute for tempera, gouache and watercolour as well as oil, and exploration of new techniques was rapidly undertaken. New Yorker Helen Frankenthaler (b. 1928), used acrylic colours dilute, to seep through and stain unprimed canvas in controlled, delicate, abstract blotches. With similar method but very different results, Morris Louis (1912–56) took Pollock's drip paintings and Frankenthaler's staining and created a very personal amalgamation. Also on unprimed canvas, he poured lines of pure, thinned colour to produce banded, translucent paintings. Counter to these bright statements, Mark Rothko (1903–70) and Robert Motherwell (1915–91) both worked intense layers of thinned, suffused acrylic to express a sense of contemplative stillness.

Up until the late 1950s, acrylics were still solvent-based, but the development of emulsion-based acrylics – like those we have now – made them suitable for general use. Acrylic was an instant hit and became the medium of choice for the contemporary painter.

Pop Art

The superficial, throwaway aesthetic of consumerism created the Pop Art ethos, and acrylic was its perfect medium, being excellent for defining hard edges, with flat, graphic colour, and a smooth plastic finish. Andy Warhol (1928–87) used it to glorify popular images and icons, and Roy Lichtenstein (b. 1923) reinvented comic-book heroes on a very grand scale using flat passages of acrylic. Acrylics were not available in Britain until the 1960s. When they arrived, young Royal College rebel David Hockney (b. 1937) exploited them with considerable inventiveness and wit, as he sought to redefine the language of rippling water in a Californian swimming pool with contrasting flat, bright, colours and textured paint marks. Bridget Riley (b. 1931) used acrylic to produce optically illusory images known as Op Art. Ideal for creating even-toned, pulsating striped patterns, acrylic's quick-drying properties prevented smudging in works so critically precise as these.

Photorealism

By the 1970s and 1980s painting had virtually turned full circle. From the traditional strivings for three-dimensional realism on the two-dimensional canvas, through the indulgent years of Abstract Expressionism when paint itself was deemed to express an inner reality, the creation of pictures was once again centring on the mastery of technique. Copying the level of realism found in photographs, Chuck Close (b. 1940) succeeded in representing portraits on a very large scale. In the field of illustration, especially in America and Japan, photorealism was the goal and was greatly acclaimed.

A new realism

At the end of the twentieth century, figurative painting was once again back in vogue, with artists seeking to recount in their work the attitudes, thoughts and feelings of life in a post-modern society. Paula Rego (b.1935) embeds psychological dramas and relationship tensions within the apparently innocent setting of traditional storytelling themes. Her handling of the medium gives her bold, hard-edged figures a frozen, sinister quality.

The quality of acrylic paint has improved hugely in the years since its inception. With the availability of retarders and other mixers, drying times have been increased, allowing greater flexibility in working, and it has also become possible to alter the constituent parts sufficiently with the addition of other media, to develop the medium and its expression still further. Some had feared that it would threaten the continuing existence of oil as a popular medium, but this has not happened; acrylic has found its own place in the artist's studio as a diverse all-rounder. Who would have thought that plastic pictures would have become a credible alternative, and in these eclectic times, who knows where the hunger to create anew might lead its development?

Tools and materials

Brushes and painting knives

There is a vast array of brushes for sale in today's art stores. There seems to be a brush for every mark you could wish to produce, and selecting the correct tool for the job is complicated by the equally extensive range of sizes, materials and prices. The right choice is important because it will influence the kind of painting you create. It is therefore worth considering your present needs carefully, rather than buying the first tool that takes your fancy. Selecting a brush that suits is a personal activity – a try-out is the best way of deciding. As you gain experience, selection will become easier – eventually you will own a small family of favourites!

Brushes for oil and acrylic painting have longer handles than their watercolour counterparts as they are usually used at an easel and held at some distance from the support. The broad range of marks produced in oil and acrylic paintings requires more extensive movement of the shoulder and elbow, and the longer handle assists this. There are exceptions – if you wanted to paint miniatures, for example, you would be better off using a short-handled brush. Soft-hair brushes – sable and synthetic – as used with watercolours, are also suitable for oils and acrylics. However, when used with acrylics they must be washed thoroughly with warm, soapy water immediately after use to avoid clogging the hairs. The synthetic types are probably best for use with acrylic, as it tends to wear out brushes more rapidly than any other medium.

The three main materials used for oil and acrylic brushes are bristle, natural hair and synthetic fibres (a simulation of the first two). Hog bristle is by far the most durable and the split ends, or 'flags', allow brushes to hold generous quantities of paint. Natural hair, having a softer texture, is unsuitable for laying coarse grounds or thick passages of paint. Synthetic brushes are very popular, being cheaper and more hardwearing than the other two types. Their fibres are also easier to clean and maintain.

There are approximately 14 different brush sizes in a series (this varies between manufacturers and is not standardized). Each has a number: the greater the number, the larger the brush. An 00 brush has just a few hairs and is useful only for minute detail, whereas a 12 has a broad 'belly' of hairs suitable for making marks over a large area.

Dipper *This very useful aluminium receptacle clips neatly on to the side of your palette so that oil or turpentine is always to hand.*

TIP

Purchase the best-quality brushes and tools you can afford, but do not buy any more than you need for the tasks in hand. You can add to them as your increasing proficiency calls for a wider range.

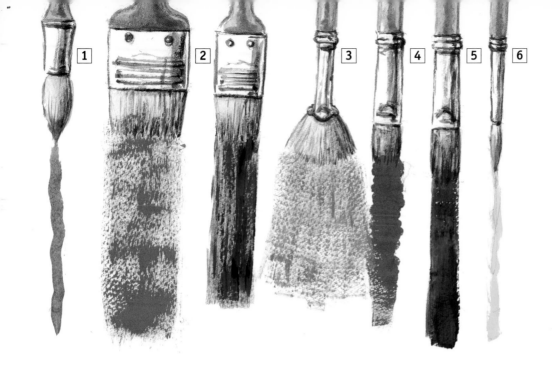

Knives

A painting knife [7] is a delicate tool with a stepped handle and flexible blade, used for mixing and spreading colour. Blades are available in a number of shapes and sizes, according to the type of mark to be made. All surfaces of the knife can be utilized: the tip is good for creating fine stippled marks, the flat underside for thick, broad, impasto strokes, and the edge for linear work.

Palette knives [8] can be used for mixing colours together on the palette, or for removing unwanted paint from a support. The blade of a palette knife is flat and flexible with a rounded tip. As with brushes, good household alternatives such as decorators' scrapers can be used, and these will render broad, painterly marks.

Brush types

Round brushes [1] have excellent paint holding capacity and taper to a point. They work best with thinly diluted paint. Ideal for initial underpainting and finer detail work.

Flat Brushes [2] are square-ended with long, flexible bristles that hold generous amounts of paint. They are most suitable for filling in larger areas of a painting and for blending.

Fan blenders [3] add finish to a painting by smoothing out hard edges and blending tones.

Brights [4] are short, flat brushes with stiffer bristles ideal for thick painting and impasto techniques. Their short hair makes them more controllable for use in detailing.

Filberts [5] are a cross between a flat and a round. The tip curves slightly, making it useful for softening edges.

Riggers [6] have very long hairs and come to a fine point. They are used for very fine detail and executing long, thin lines.

Other types

Household decorating brushes can be useful alternatives to the main brush types. Always be on the lookout for other domestic brushes that might be put to an artistic use.

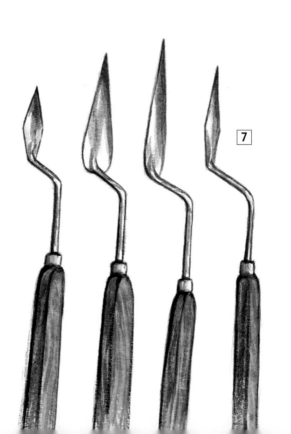

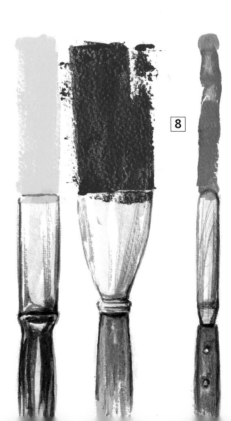

Paints – oils

The most traditional and permanent of all painting media, oil has the power to charm those who try it. However, it does have specific requirements for usage, so it is good to have some knowledge of oil paint's unique properties. By grinding dry pigments into a natural oil such as linseed, it is possible to create your own oil paints; some professionals believe these to be far superior to the shop-bought varieties. Either way, the source remains the same: natural earth pigments are mined and manufactured to give us reds, browns and yellow ochres. Inorganic pigments like cobalt blue or viridian are chemically made, and organic colours such as purple madder are extracted from dyes.

TIP

Some colours are not permanent and may fade under strong light conditions – these are known as 'fugitive' colours. Manufacturers use a coding system, clearly printed on the product, to indicate the permanence of the colour, and this can be checked against their catalogue.

Commonly sold in tubes, oil paint is available in either students' or artists' quality. There is usually a smaller choice of colours within the students' quality range, and they contain less pigment. Although cheaper to buy and good enough for the novice, their performance can be variable. It is much better to begin by purchasing a limited selection of colours from the artists' range, and then build your collection gradually. Prices of paints vary hugely, dependent upon the cost

of the raw material used for the paint. Modern alternatives to the expensive traditional pigments are available, and they may well suit your painting needs.

Recent additions to the range of available products are water-soluble oil paints. These share the properties and character of oil paint, but unlike traditional recipes, they do not require turpentine or white spirit to thin them down or to clean brushes.

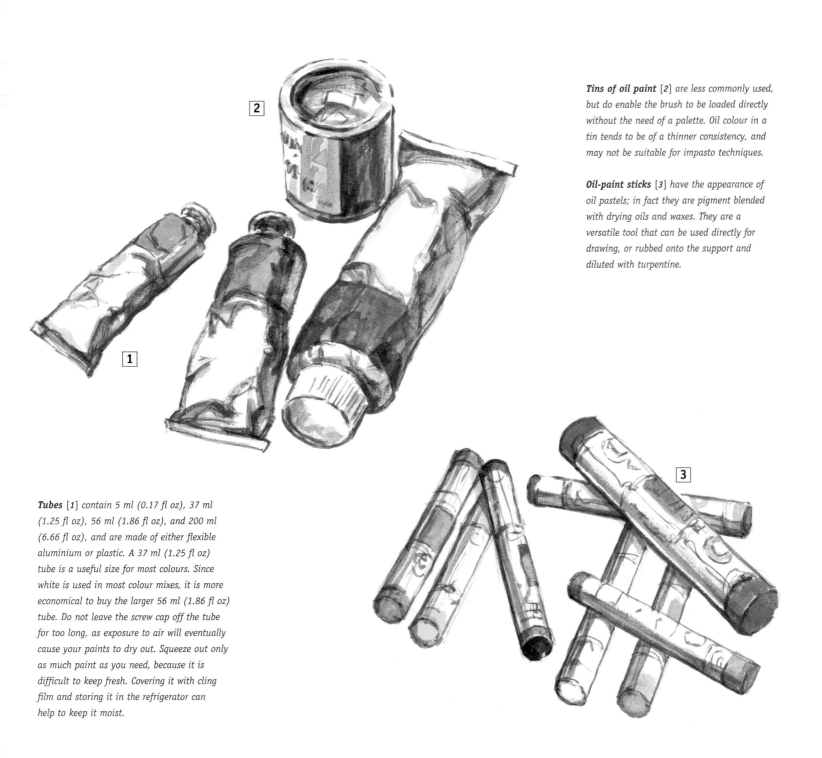

Tins of oil paint [2] *are less commonly used, but do enable the brush to be loaded directly without the need of a palette. Oil colour in a tin tends to be of a thinner consistency, and may not be suitable for impasto techniques.*

Oil-paint sticks [3] *have the appearance of oil pastels; in fact they are pigment blended with drying oils and waxes. They are a versatile tool that can be used directly for drawing, or rubbed onto the support and diluted with turpentine.*

Tubes [1] *contain 5 ml (0.17 fl oz), 37 ml (1.25 fl oz), 56 ml (1.86 fl oz), and 200 ml (6.66 fl oz), and are made of either flexible aluminium or plastic. A 37 ml (1.25 fl oz) tube is a useful size for most colours. Since white is used in most colour mixes, it is more economical to buy the larger 56 ml (1.86 fl oz) tube. Do not leave the screw cap off the tube for too long, as exposure to air will eventually cause your paints to dry out. Squeeze out only as much paint as you need, because it is difficult to keep fresh. Covering it with cling film and storing it in the refrigerator can help to keep it moist.*

Paints – acrylics

Acrylic paint is still developing and improving with advances in manufacturing technology. It is a synthetic medium with many of the qualities of its traditional partner, oil. Being latex or polymer (plastic) based, acrylic is flexible, richly saturated in colour, and opaque with a viscous texture. When thinned with water it produces transparent washes. Drying time is always rapid, and this demands an energetic and pacey approach from the artist.

Acrylic paint consists of pigment bound in a polymer emulsion. This is a synthetic chemical resin, bearing highly elastic properties. Polymer particles are stored suspended in water, which gives the paint its fluidity. When the water evaporates the particles form a flexible, hard and inert film that adheres to most surfaces, and it is water-resistant, allowing new layers to be added without disturbing those beneath. The range of acrylic colours available is as extensive as for oils; in addition there is a range of fluorescent and metallic colours. Acrylics can be purchased from students' and artists' quality ranges. The least expensive acrylics come in the form of polyvinyl acetate or PVA paints. PVA as a medium is most commonly associated with its adhesive formulation 'white glue'. When the medium is diluted and added to powder pigment, a good acrylic substitute is created.

*As with oil paint, **tubes** [1] contain 5 ml (0.17 fl oz), 37 ml (1.25 fl oz), 56 ml (1.86 fl oz), and 200 ml (6.66 fl oz), and are made of either flexible aluminium or plastic. Again, a 37 ml tube is a useful size for most colours, with a 56 ml tube recommended for white. If the cap is left off a tube, the paint will swiftly dry out and be completely useless. Tube paint is the thickest in consistency and therefore the nearest to oil in texture.*

*Larger quantities of acrylic can be bought in **jars** [2] when it is needed for bigger work or greater economy. However, be careful not to buy too much of a colour that you will not be using very often. Jar acrylic is smoother and more fluid than tube paint.*

***Squeezy plastic bottles** [3] have a tapered nozzle that assists the pouring of the paint either directly onto the support or onto the palette.*

Liquid acrylic colour comes in small bottles with dropper caps. It is very fluid and highly concentrated, making it ideal for laying transparent washes as you might using watercolour.

TIP

Make sure that you wash out all
brushes thoroughly with warm,
soapy water immediately after
use with acrylic paints. The
plastic base of the medium will
clog the hairs and dry hard if
brushes are not cleaned properly.

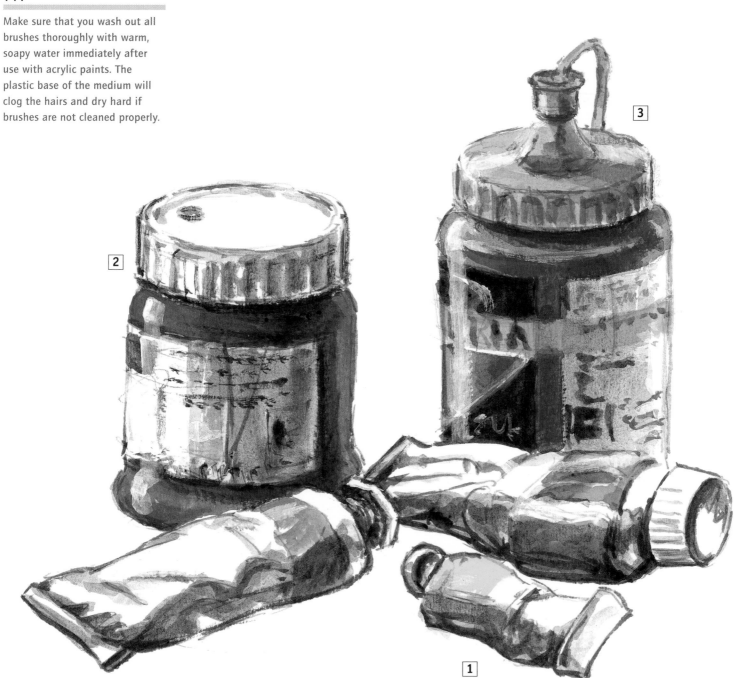

Other media

Oil and acrylic paints combine well with other wet and dry drawing and painting media. Often, the integration of one or two other materials can give a piece of work real spark and edge by accentuating certain details or introducing textural contrasts. Some budding artists are worried by the apparent unpredictability of mixing media. But trying new techniques and approaches is exciting and helps to build confidence.

TIP

Always test your media combinations on a surplus piece of your chosen support to confirm their compatibility.

Media for both oil and acrylic

Pencils [1] *are the most basic mark maker. They are excellent for preliminary drawings and light, sketchy planning on paper and canvas. The full range of H and B grades give a broad band of tonal marks that can accent the liveliest acrylic painting, particularly where the paint has been laid in thin washes. Pencil does not, however, mix well with impastoed oil or acrylic. Water-soluble pencils are superb blenders, and are available in a wide range of colours. They can be used dry, by dipping the tips into water, or softened down with a wet brush.*

Charcoal [2] *can be softly smudged or expressively bold. These sticks of oven-fired willow partner both oil and acrylic in the opening stages of any painting. As a charcoal design is worked up on the paper or canvas, mistakes can be corrected easily by smudging out and redrawing. It is also available in pencil form, making it more controllable for sharper lines. Charcoal is enormously versatile, allowing the creation of a wide range of tones from black to silver-grey. This makes it an important aid to expression.*

Oil pastel [3] *drawn onto an acrylic painting will adhere to the surface and deposit a waxy, broken texture. If diluted acrylic is flowed over oil pastel, it will be repelled in a process known as resisting. When accompanying oil, it serves in a more complementary role, and can be successfully employed for the execution of finer detail.*

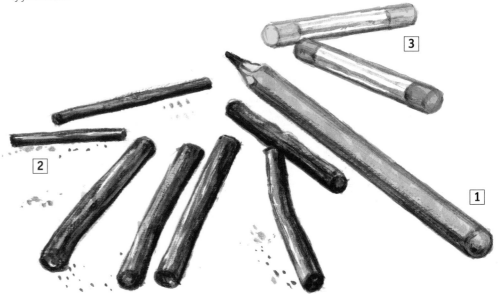

Media for acrylic only

Some media will not mix with oil paint. These are all water-soluble materials, or dry media containing less binder.

Ink [4] is available waterproof, such as Indian ink, or non-waterproof, such as fountain-pen ink, and in a wide range of colours. Use waterproof where you do not want your marks to run when another wet layer is applied on top. Lines can be drawn over painted areas with a nib-pen or brush. Waterproof inks contain a gummy varnish called shellac, which gives a hard, glossy sheen. Because shellac can clog nibs and brushes, they should be washed immediately after use in warm, soapy water. Non-waterproof inks flow well over existing washes and dry with a matt finish. They will have only a limited effect on the impermeable crust of thick acrylic paint.

Pastel sticks [5] are powdered pigment, loosely bound with a weak gum or resin. There are two types – hard and soft – and both crumble onto the support leaving a smooth, yet gritty texture. It is this texture that can add extra depth and interest to a flat, acrylic-glazed surface. Broken-colour techniques can be exploited on coarsely woven canvas or rough paper. Hard pastels are best suited to the creation of lines and flat colour. Both should be fixed with a specially formulated spray to avoid smudging.

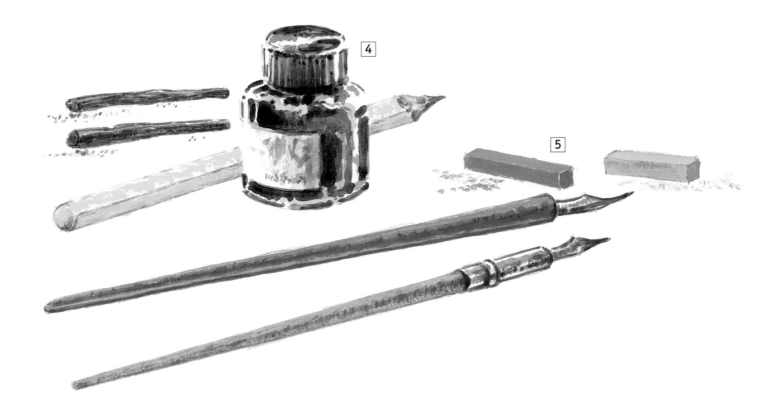

Painting mediums

Both oil and acrylic paints can be used straight from the tube, but more often they are combined with either a medium, a diluent, or a combination of both. The purpose of mediums is to change or enhance properties of the paint such as consistency, drying speed and overall finish. Discovering which medium suits your style is a matter of trial and error.

Painting fat-over-lean

When underpainting in oils, it is important to use 'lean' paint, mixed with turpentine and no oil. As the painting builds, you may add an increasingly greater proportion of of oil to make the paint 'fat'. A ratio of sixty per cent oil to forty per cent turpentine is the norm. This is called painting 'fat-over-lean', a sound traditional principle which prevents the paint from cracking upon drying. (Oily paint dries slowly and shrinks a little as it does so; if lean paint is applied over it, the top layer dries before the underlayer has stopped shrinking, and can crack or even flake off.)

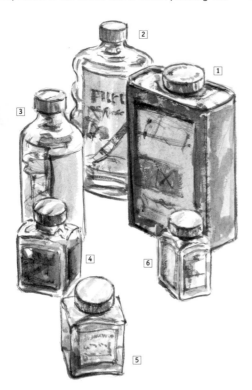

Oil diluents

Diluents, or thinners, are liquids used to thin down oil paints. They may be used alone, or in combination with an oil such as linseed oil. **Turpentine** [1] *is the most commonly used diluent. Always use distilled turpentine for painting purposes. Ordinary household turpentine is not suitable because it yellows and makes the paint sticky (though it is fine for rinsing brushes and cleaning).*

White spirit [2] *has a petroleum base and evaporates quickly. As a diluent it is less noxious than turpentine, has a longer shelf life and a less pungent odour.*

Mediums for oil painting

A wide variety of manufactured mediums are available, but to begin with all you need is a bottle of turpentine and a bottle of linseed oil.

Linseed oil [3] *Derived from the crushed seeds of the flax plant, linseed oil gives oil paint its thick consistency and helps to bind the pigments. Although it appears to dry quickly, the full process can take years, and colours become more transparent as this occurs.*

Poppy oil [4] *is used to slow down the drying of certain pigments. It is a pale, colourless oil and is often used to bind white and other light colours because it tends not to turn yellow. It should not be used for underpainting because of its slow-drying properties.*

Alkyd [5] *is a synthetic resin that significantly speeds up drying time and increases paint flexibility. Because of this, it is favoured for heavy, impasto work. Alkyds can also be thinned with turpentine or white spirit.*

Glaze medium [6] *adds brilliance to thin glazes. It uses a particular form of linseed called 'stand-oil', which can take up to five days to dry, even in a thin layer.*

Beeswax medium *is an additive that increases the volume of paint by thickening it. Use only natural, purified beeswax. Slowly heat about 100 g (3.5 oz) in a can on a stove at a low temperature; once it has liquefied add it to 85 ml (3 fl oz) of turpentine. When cool, the mixture should be stored in a closed jar.*

SAFETY TIP

Keep the room well ventilated when using any solvent-based products such as white spirit and turpentine. Also avoid contact with the skin through which they can be absorbed.

Mediums for acrylic painting

Acrylic paints can simply be thinned with water, but there are various acrylic mediums available which can be mixed with the paint to improve its flow, control its drying rate and alter its consistency. The mediums have a milky appearance, but become transparent when dry.

Gloss medium increases the flow of the paint and enhances the depth and vibrancy of colour. This luminosity is in part due to the paint becoming more transparent, allowing for the build up of thin glazes, and it dries to a soft, silky finish.

Matt medium is similar to gloss medium but with added wax emulsion. The surface will dry to a matt, non-reflective finish. Try mixing matt and gloss mediums together to experiment with a variety of finishes.

Gel medium comes in a paste and thickens the consistency of acrylic to make it perfect for impasto work and knife painting. It also increases the paint's adhesive qualities, making it ideal for use in collage.

Texture paste is even thicker than gel medium and creates paint that can be trowelled onto the support with a knife. It is very effective for relief pictures and can be carved or sculpted. This paste can be mixed into all acrylic colours and given exciting textures through the addition of materials such as sand, grit and sawdust. It is also possible to create heavier collage work with embedded objects using this medium.

Retarding medium increases the drying time of acrylic, allowing more control over the paint and simulating the process of painting in oil. Only a little retarder is necessary for effective use. Work with a ratio of one part retarder to six parts earth colour, and one part retarder to three parts all other colours.

Flow improver thins acrylic right down without destroying its rich colour value. It greatly increases flow across larger areas and is therefore good for laying broad, even washes.

Acrylic varnish is available in both matt and gloss finish. Unlike acrylic mediums, which should not be used as varnishes, this varnish can be cleaned with warm soapy water and removed with white spirit.

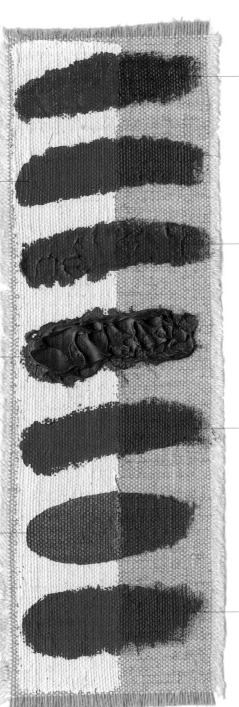

Papers and other supports

The surface or support you choose to use and its preparation, will strongly direct the way you paint. Different surfaces produce unique textures, and these can inspire your choice of media. A vast array of papers, panels and canvases is at your disposal and selecting the most suitable for the job is not as difficult as it may at first seem. Learning a little about the properties of each one should help you to make the correct choice.

Supports for oil and acrylic

It is essential to prepare a support properly for either oil paint or acrylic paint (see page 26). The simple rule for acrylic surfaces is that oil and water do not mix. If your support is grease, wax and oil free, the plastic emulsion base should adhere to the surface. After all, acrylic was developed in the 1950s for mural painters working on external walls!

While the saturation and deep-colour value of oil paint cannot be matched by any other medium, it is far less durable than acrylic, and lacks the flexibility provided by its synthetic base. However, this is not a problem if the support is prepared correctly. A thin layer of size applied to any surface will prevent the oil binder from sinking into the paper or canvas. Without binder, the pigment is unsupported and liable to crack or flake away. An incorrect support or poor preparation can seriously reduce the longevity of an oil work.

Papers

Most papers are suitable for small and medium-sized work. However, a sheet must be heavy enough to take the movement of paint strokes and prevent buckling. Stretching paper stops this.

*When stretched, **cartridge paper** is perfectly adequate for most uses. It is fairly smooth with a fine grain and is available in a number of different colours. It is absorbent and has its own internal sizing to prevent paint spreading and sinking below the surface.*

*Bockingford **watercolour paper** [1] is a good choice for artists of all levels. Hot-pressed papers have a very smooth surface devised for fine work and feel slippery under the brush, whereas cold-pressed (or 'Not') papers have good all-round surfaces. Avoid buying expensive hand-made watercolour papers – their high quality is unlikely to enhance acrylic techniques.*

*Many inexpensive **hand-made and Indian papers**, such as 'khadi', have a high cotton content. Some even have*

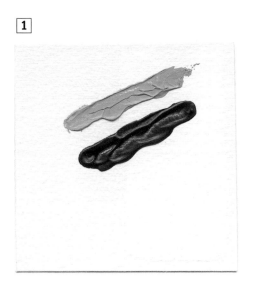

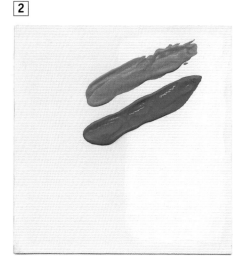

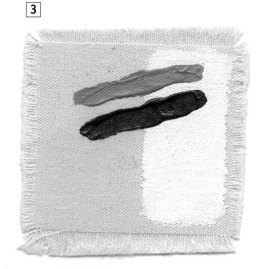

TIP

Take the time to prepare the supports that you use properly. This will greatly increase the longevity of the work.

organic materials like petals and grasses woven into their structure. Their sizing is often poor, so it is advisable to prepare such papers with a couple of thin coats of emulsion glaze or PVA medium.

Acrylic papers [2] are specially prepared with a strong grain running throughout. Pre-primed for acrylic, they are ideal for rapid sketches and small outdoor paintings.

Canvas

When stretched, canvas offers a taut, sprung surface, which can be highly invigorating to work on. It can be bought ready-primed for acrylic or oil, but always check because oil-primed canvas is unusable for acrylics. Available single- or double-primed, the former is less expensive, less dense and more flexible.

A cheaper alternative to linen, **duck cotton** [3] is a good all-rounder but may not stretch as well. It often has knots in the weave, and can sag over time. Available in various weights, it does however suit the general needs of most hobbying painters.

With its fine, even weave and reliable stretching properties, **artist's linen** [4] is the best and most expensive fabric support available. Its brownish colour can be seen as an integral feature of some paintings.

Hessian is a very coarse jute weave and is best when used with thick brushwork. It requires heavy priming.

Similar to hessian but slightly finer in its weave, **flax** [5] tends to suit the more physical painter who wishes to exploit texture and surface. It is relatively inexpensive and, like linen, usually has a light brown base colour.

The use of **unprimed canvas** was popularised in the 1960s by the internationally acclaimed painter David Hockney. At the time, this was an unusual way of using canvas. Even when using acrylic paints, it is still advisable to seal the canvas using light coats of diluted acrylic emulsion glaze or PVA medium, to prevent paint bleeding.

Marouflaging [6] is the process by which canvas is stuck to a board, combining the feel of working on canvas with the rigidity of a firm surface. Any natural fabric can be used: stick it to the board using PVA glue or, with oils, a special adhesive called 'glue size'.

Panels

Cardboard, hardwood, plywood, chipboard and micro-density fibreboard (MDF) are all suitable for painting with acrylic. These surfaces must be clean, dry and primed before use (see page 26). As well as sealing the board, this serves to provide a welcoming, opaque white surface.

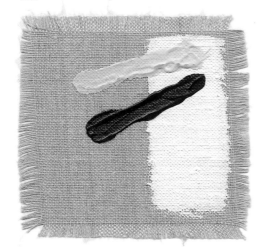

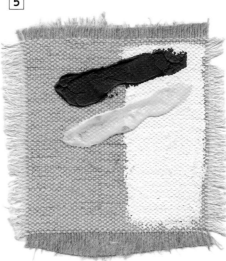

Stretching canvas

You can choose between purchasing a canvas that has been ready stretched, sized and primed, or you can create your own. If you decide that you would like to make your own, a good art supplier will stock various lengths of interlocking 'stretcher' pieces. These are the flat, wooden batons that create the frame over which the canvas is stretched. You will need to decide on the frame size that you want before you buy the necessary stretcher pieces and canvas. Always buy a little more canvas than you need – just to be safe!

Sizing and priming

All the supports mentioned on the previous pages are suitable for oil painting, but need to have their fibres sealed with a specially formulated glue known as size. After stretching and sizing a canvas it must be primed with at least two coats of primer. Make sure you allow time for the first coat to dry, and then lightly smooth it with glass paper before applying the second.

Sizing and priming provides a good surface to paint on and a protective layer between the support and the oil paint, which might otherwise rot the canvas. If an acrylic primer is used, no sizing is necessary, as these are designed to adhere to untreated surfaces. Acrylic primer is the ideal surface for acrylic paints (but it should not be used over animal-glue size).

Rabbit-skin size *Traditionally, size is made from rabbit skin and comes in granule form. It has to be soaked in water, gently heated and then simmered. When the mixture cools, it forms a jelly that is ready to spread onto the support. The size-to-water ratio is important, so the manufacturer's guidelines should be followed carefully. Making large amounts of size in one session is fine, as it can be stored in the refrigerator for up to a week. When heated, the solution does emit an unpleasantly pungent smell, so this is best done when it won't inconvenience others and preferably away from living areas.*

Priming *When applying oil or acrylic primer, work from the edges with broad strokes using a large bristle brush or decorator's brush, or a roller. When the first coat of primer is dry, apply the next coat at right angles to the first. Up to five thin coats can be applied for a really smooth finish.*

Select stretcher pieces to suit your composition and carefully slot them together. Make sure they are at right angles (if you have a set-square check them with this).

Cut out your canvas to fit the frame, allowing a margin of about 10 cm (4 in) all round for stapling. Lay the stretcher frame on the canvas.

Staple from the centre of one side, stretching the material and fastening to the opposite stretcher piece: repeat the process with the other two sides, then continue from one side to the other, working towards the corners. Make sure the tension is even and that the weave of the canvas is straight.

Carefully pleat in the corners and check there is no puckering on the front face of the canvas. Insert the wedges but do not hammer them in. Next, size and prime the canvas. If necessary, once the primer has dried, gently tap in the wedges to remove any slack and repeat when required. However, never overtighten the canvas, as it can tear.

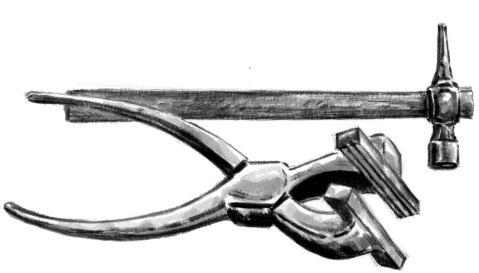

Stretching paper

When acrylic paints are thinly diluted with water or medium they can be applied in much the same way as traditional watercolours. If you are working on a lightweight cartridge paper or watercolour paper, it will need to be stretched before you begin painting, to prevent it from buckling or 'cockling' when the wet washes are applied. Stretching paper is not a difficult task, as long as you follow the correct procedure and allow plenty of time.

Wet paint causes paper fibres to swell; often the structure of the paper is not flexible enough to allow it to shrink back to its original shape and size, resulting in cockling. This is avoidable when the paper is held tightly in place as it shrinks, like the skin of a drum. Once shrunk, the paper will always return to this taut state when saturated by paint. Lightweight papers need to be stretched or they will buckle when wet paint is applied. Papers of 150 gsm (72 lb) to 300 gsm (140 lb) must be

soaked in a bath or tray of water for several minutes before being taped onto a wooden board with gummed paper tape, known as 'gum-strip.' With heavier papers there is less need for stretching, unless you intend to apply a lot of heavy, wet-in-wet washes.

Stretching paper requires pre-planning as the paper takes at least two hours to dry; you will need to take this into account and ideally prepare your paper the day before you intend painting.

TIP

Avoid drying your paper in front of an open fire. This is dangerous and paper can peel off under extreme heat. A hairdryer is a safer and better method.

Cut four lengths of gum-strip 5 cm (2 in) longer than the edges of your paper. Check that the paper will fit the board, remembering to allow a margin at the edges for the gum-strip. Immerse the paper for several minutes to soak it fully. Use a container large enough to allow the sheet to lay flat. Check that both sides have been fully immersed.

Evenly dampen the board that you are using to stretch the paper. Lift the paper gently out of the water, holding it by the corners, and allow excess water to drain away. Carefully lay the paper as centrally as possible (and correct side up) onto the dampened board.

Smooth the paper out from the centre, ensuring that it is as flat on the board as possible. Moisten (do not saturate) each length of gum-strip with a damp sponge immediately before use.

Stick a strip along each edge, beginning with the two long sides and with half the width of the strip on the paper, half on the board. If you do not follow this procedure, the paper is likely to pull away as it dries. Run your finger firmly along the tape with an even pressure to ensure that it is firmly fixed. Allow the paper to dry naturally and away from strong, direct heat; any disturbance may damage the surface or cause the paper to tear or crack. Do not use newly stretched paper until it is completely dry.

Your palette

However you come to choose your preferred colours, whether by taking advice or by trial and error, the evolution of your palette will result in a unique selection. All artists have their favourites and are likely to disagree to an extent over which colours are essential, but certain colours appear in every paintbox. The earth pigments: umbers, siennas and ochres have no substitutes, and mineral blues and greens cannot be matched by chemical formulations. Made from ancient recipes, these artists' colours have proved reliable over hundreds of years of practice. Today they are complemented by the brilliance of modern, synthetic pigments. Both line the shelves of artists' studios the world over, and supply a well-balanced palette.

TIP

To begin with, buy small tubes of colour. Then, when you know which colours work for you, buy them in bigger tubes, which are better value for money.

It makes sense to buy the minimum number of paints and mix them together to produce a maximum number of colours. Apart from saving you money, this will give your paintings a pleasing harmony and unity. Having too many colours can be confusing and counter-productive; boxed sets of paints, in particular, often contain too many disparate colours, some of which are quite unnecessary.

My own choice of eight colours, shown on the opposite page, makes a good 'starter' palette for both oils and acrylics, and should provide an adequate mix of colours for most purposes. It is important to lay out your colours on the palette in a systematic order so that you don't confuse them when mixing. My colours are arranged from light to dark; some artists prefer to arrange their colours from warm to cool, or in the order of the spectrum.

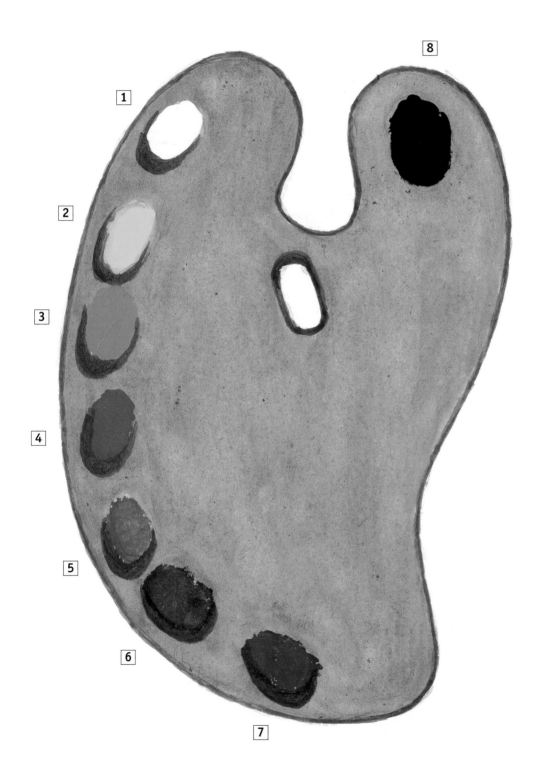

Titanium white *(acrylic) or* **flake white** *[1], the latter preferred in oil because it dries in just two days as opposed to titanium's five to eight days. Both have excellent light permanence and high opacity, and retain their intensity when mixed with other colours.*

Cadmium yellow *[2] is extremely lightfast, with good covering power and tinting strength, but is very slow drying – approximately five to eight days. It is slightly warmer and redder than other yellows.*

Burnt umber *[3] has good lightfastness, like all the umbers, which are fairly opaque with a solid earth base. However, they can darken down when the oil dries. Has a relatively fast drying time of a couple of days.*

Cadmium red *[4] is a brilliant red that mixes with cadmium yellow to produce a pure orange, identical to cadmium orange. A dense, opaque colour with good tinting strength.*

Viridian *[5] is a cool, bluish green. It has excellent lightfastness, and although fairly transparent, has good tinting strength. It is slow drying and takes around five days.*

Prussian blue *[6] is the least lightfast and will fade under strong ultraviolet light. However, it does have excellent mixing qualities and a fast drying time of approximately two days.*

French ultramarine *[7] is a warm, transparent colour with high lightfastness and a medium to slow drying time. Its versatility as a colour is expressed through its mixing abilities, especially with burnt umber.*

Ivory black *[8] is highly lightfast with strong opacity. It tints well but has a very slow drying time of five to eight days. When yellow is mixed with this black it makes a most unusual deep, velvety green.*

Colour theory

We are naturally equipped to read and respond to colour in its various combinations. Colour can induce powerful responses: the colour of our immediate environment can affect us emotionally, and even affect our behaviour. Because it is so powerful, artists need to understand the basic science of colour, as laid down in theories dating back to Isaac Newton in the seventeenth century, and implemented by Jacob Le Blon (1667–1741) in the early eighteenth century. By knowing the theories surrounding colour, more deliberate choices can be made when painting pictures, and the desired outcome is more achievable. Of course, our responses to colour are to some extent individual, hence the use of colour when painting will be subject to personal preference and experimentation.

The language of colour

It is useful to know and be able to use the special terms that relate to the properties and characteristics of colour. *Hue* is the standard name for a colour, such as cadmium yellow or alizarin crimson, and refers to the pigment in its pre-manufactured state.

Saturation or *chroma*, refers to the intensity and purity of a colour. Cadmium yellow, cadmium red and French ultramarine are all highly saturated colours and those closest to the purest pigments of yellow, red and blue – known collectively as the primary colours.

The intensity of a colour can be reduced by dilution with water or medium; by mixing it with white or a lighter colour to produce a *tint*; by mixing it with black or a darker colour to produce a *shade*; or by adding some of the colour's complementary to neutralize it.

The relative darkness or lightness of a colour is referred to as its *tonal value* and varies according to the amount of light falling on it.

Colour temperature is an apt description of the warmth or coolness of a colour. Warm colours such as red, yellow and orange are associated with sunlight, and cool colours such as blue, violet and green are associated with shadow. If you place a warm hue next to a much hotter one, it will appear relatively cool, and vice-versa.

Warm colours appear to advance and cool colours to recede. This principle can be used to describe space and form in your paintings. In landscapes, for instance, the contrast of warm, advancing colours in the foreground and cool, receding colours in the background helps to create the illusion of depth and distance.

Colour wheel

The colour wheel shown here is created with the purest, saturated colour, blending its way from red to violet, via orange, yellow, green and blue. The colours contrast most strongly with their opposites on the wheel: for example, orange is opposite blue. The most harmonious combinations are next to one another, for example, yellow and orange.

The primary colours are red, yellow and blue, and in theory it is not possible to mix these colours from any others. By mixing the primaries together, you should be able to mix any other colour.

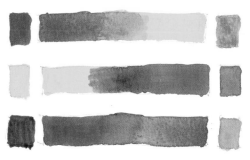

Secondary colours are created when two primaries are mixed together in equal quantities. Thus, yellow and red make orange, yellow and blue make green, and red and blue make violet. Note that your choice of primaries dictates the tone and temperature of the secondary created. Here, Prussian blue and alizarin crimson have produced a very warm violet.

Tertiary colours are created when a primary and a secondary are mixed together. This produces orangey-yellows, reddish-oranges, yellowish-greens and so on. These subtler tints create warmth or coolness in a painting. They are positioned between the primaries and secondaries on the colour wheel.

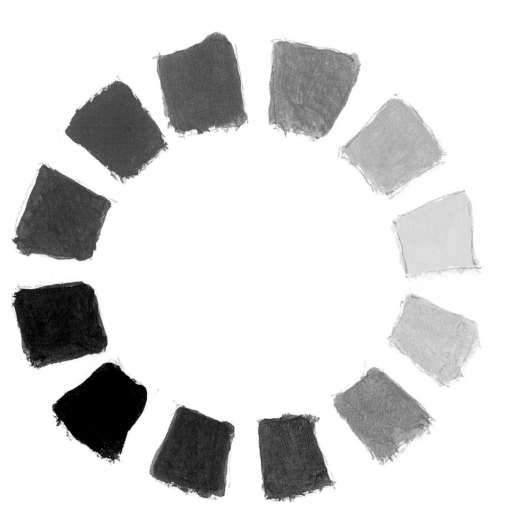

Complementary colours comprise a primary colour and the secondary opposite it on the wheel. They have the strongest contrasts. Yellow and violet, red and green, and blue and orange are the three pairs of complementary colours. More generally, any opposing colours are often called complementary.

Learning about tone

Tone is the term given to the various gradations of grey that exist between the absolutes of lightness (white) and darkness (black). This term also applies to similar values perceived within light and dark colours. Here it is known as 'tonal value' and its use within all forms of drawing and painting is the key to the successful description of space, light, depth and volume.

All tonal values are relative to light and the surrounding colours. If you look at a landscape, for example, it can be hard to assess the dark and light areas: a mid-toned green tree may appear light against a dark-violet copse of surrounding trees. If the same copse is covered in a light-blue filmy mist at a different time of the day, the same mid-toned tree appears a lot darker. Light can dramatically change the appearance of colours and a very dark hue under reflected sun might appear very bright – perhaps the lightest part of a working composition. The contrast between two tonal values may be used to give 'weighting' to elements in a composition. The greater the contrast – a white, solid object under a strong directional light source set against its black,

spreading shadow – the greater the weight of that object. Paint a strip of yellow next to a warm red on a sheet of plain paper. As colour values, they will contrast against one another. However, if the same colours are scanned onto a computer as a greyscale image, or photographed using black and white film, their tones will appear almost identical.

Coloured neutrals are the most natural forms of grey because they hint at the colours that form them. Mix any primary colour (saturated) to a secondary or tertiary colour (unsaturated) and the resultant colour will be a coloured grey. The primary will always be the prominent colour showing through. A full tonal range of greys can be created by either diluting the mix or adding white.

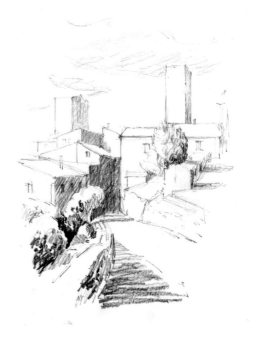

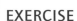 **EXERCISE**

In a notebook, create tonal scales by drawing a row of boxes into which you add gradations of mixed grey. To achieve this, squeeze a primary colour, blue for example, onto the palette, and repeat with red. On the palette, mix a little red to the blue, producing a violet. Add this violet (secondary) to the blue

(primary) to make a grey. Paint this into your first box, then, as you work along the row of boxes, add more of the secondary to the mix and note the tonal changes. Try a variety of different colours. Always caption your exercises with simple written notes on the colours and quantities used.

Italian town

In their simple, architectural beauty, the medieval towers of San Gimignano in Italy become perfect reflectors of changing light, displaying through tonal nuances both stark and subtle ranges of tonal value. I painted this scene in acrylic and body colour (gouache), enjoying the different qualities of mark that were achievable by mixing the media. Reducing the colour palette to warm sepia tones helped to simplify tonal colour complexities, thereby focusing attention on the composition's form and structure.

Washed sepia and generous amounts of white gouache added with broad, gestural brushstrokes help avoid total flatness in the sky.

Subtle staining of paper with thinned acrylic wash, built up with impasto acrylic and added white gouache to describe the texture of stone walls.

Detail is unnecessary around these buildings. Their description is complete with simple dark, shadowy window recesses.

Shrubs are indicated with flat washes of sepia acrylic, layered with short, flecked strokes of thicker, darker paint, indicating shade beneath the spreading foliage.

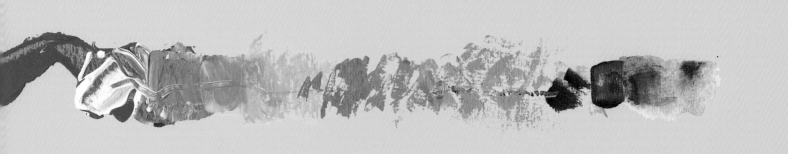

Techniques

Brushmarks

There is a great variation in the way oil and acrylic paints respond; this is dependent on a number of factors. The consistency of the paint – squeezed directly from the tube or heavily diluted – and the texture of the surface to which it is being applied, can make the same media look very different. Attention to brushwork is important to the success of your paintings: by doing so to exploit the physical properties of paint, you will be joining an admirable lineage of painters.

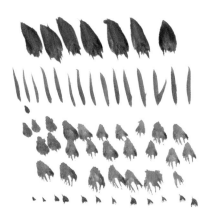

*Begin with a synthetic **round** such as a no. 8. Make a row of vertical strokes in a single colour, with a light pressure applied to the end nearest the ferrule (the metal collar that attaches the bristles to the handle). Note how the strokes are long and even, tapering to a point at each end. By adding greater pressure and gripping the brush further back towards the non-bristle end, the marks spread into broad strokes. When water is added to acrylic (or turpentine to oil), the paint assumes a much wetter consistency, and the same vertical row gives the appearance of birds' feet, caused by the hairs of the brush separating as they hit the painting surface.*

__Flats__ make the broadest of all the brush strokes. A no. 16 hog flat has considerable covering power, and is best suited for use in the structural layer of any composition. Forms created with slabs of flat brushwork can add a real sense of depth and construction to landscapes, townscapes, and most appropriately, figure studies. Experiment with the contrast between the sharp edge of the brush tip and the wide, flat side. This gives scope for considerable 'brush ballet'. Dance your strokes across the surface, altering your pressure and grip as you go to choreograph a lively sequence of paint marks!

*The unique characteristic stroke of a **filbert** is a flat paint mark, with a slightly rounded front edge. This makes it a flexible tool, performing a dual role for painting with broad, flat sweeps, but also expressing detail with more delicate turns of the brush tip. Try drawing with the tip, then filling in with the brush body.*

TIP

Compare the ways in which these brush techniques work together, by including them all in an acrylic and an oil study. Keep the two studies for future reference.

Other marks for oil and acrylic

Scumbling grounds the working surface with an inviting coloured texture onto which paint can be laid. Slightly thinned pigment is loosely scrubbed into the support with circular, directional strokes of the brush. The technique is best employed where an all-pervading ambience or mood is required.

Blending is where one hue is gently dissolved into another, usually producing a third colour in a middle band where the two meet. Keeping the brush fairly dry, gently work one colour into the other, releasing the pressure at the point of merging. If painting onto a rough surface, the blend can be an optical effect by virtue of the broken colour. Experiment by blending with different consistencies of paint.

Pointillism evolved out of nineteenth-century impressionism. Its leading exponent, Georges Seurat, explored the idea that regular dots or dashes in at least two different colours, with regular spacing between them, could portray the luminosity of light. Observed from a distance, the eye blends the dots, creating a more stimulating colour than would result if the hues were physically mixed together.

Dry brush is a technique applicable to both oil and acrylic, and when used on a coarse-grained support, produces the appearance of broken colour. Excellent for foliage and light reflections on water, it simply involves dragging a dry brush across the surface, all the while maintaining control with minimal water and small amounts of paint. With both media, light can successfully be laid over dark and vice-versa.

By using a combination of these brush techniques, layers of oil or acrylic paint can be created that exude depth, vibrancy and expression. Try each of the techniques discussed on these pages in turn, then put them all together in one experimental piece.

The type of brush you use is crucially important, as each one will leave a different kind of stroke, according to the soft or coarse material from which it is made. Paint behaviour is also dependent upon the speed and nature of application. Using the side of the brush will create a broader mark than one made with the tip. Rapidly skimming across the surface results in what is known as 'broken' brushwork.

Central to traditional painting was the methodical building of layers of transparent colour glazes. Jan Van Eyck (1390–1441), Giovanni Bellini (1430–1516) and Titian (1490–1576), all built up works in gauzy layers of ambient colour. As each hue was laid down, the previous one was allowed to show through. The authority and physical presence of paint was exercised in this way right up until the seventeenth century.

Washes and glazes

Glazing is one of the founding techniques of traditional painting. In the formative years of panel and canvas painting, it not only provided a means of enriching colour, but was also used to mix colour directly on the painting surface without the need of a palette. Successive thinned coats of transparent pigment are applied to modify the colour of each layer resting beneath, and although the visual effect is one of full-bodied intensity, the paint still retains a remarkably glassy transparency.

Glazing with acrylics

Many artists only use glazes in the initial phase of an acrylic work – a habit probably encouraged by the rapid drying times of the paint. Acrylic is usually mixed with either water or a glaze medium. It is best to add the medium in small quantities to equally small amounts of paint, and then stir in thoroughly with a brush. Layers should always be thin, so that the underlying colour shows through.

Glazing with oils

The oldest method of glazing was to build an entire painting with successive layers of glaze. Modern trends dictate a more diverse approach through the combination of direct, opaque brushwork and glazing. An underpainting in monochrome is recommended, but this could take several days to dry, and many artists today prefer to undertake this part of the process in acrylic, which can be dry in less than an hour. To make the glaze, mix linseed oil and a little turpentine with the paint, or if preferred, one of the excellent pre-prepared, alkyd mediums such as 'Liquin'. Drying time can be halved if a medium is added to the paint, allowing layers to be built up quickly. Keeping the paint thin allows for some modification if required, but always allow one layer to fully dry out before adding another.

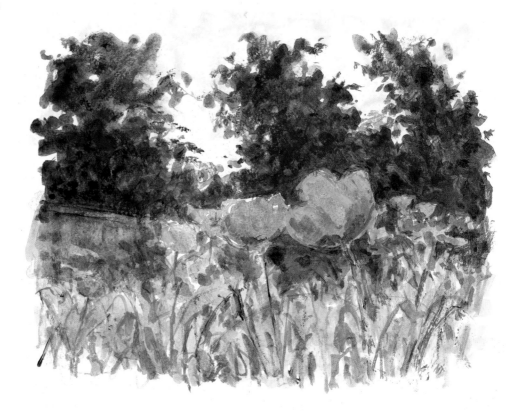

Start glazing

On several sheets of paper practise glazing in both oil and acrylic. Use a special oil-primed paper for oil paint, and clean your tools before changing mediums. During this exercise you should discover how the transparency of the colours alters as you make layers. Try out different colour combinations and alter the dilution of your glazes. Feel free to experiment with paint mediums and remember to record all your finds, preferably with written notes beside the swatches.

These poppies in a field were worked up from a simple compositional charcoal sketch. Such a sketch could be the basis of your picture, drawn onto your painting surface or acting as a close reference guide for your actual artwork. Charcoal can be easily scrubbed out to allow for alterations.

Thin glazes were worked up successively across the whole surface in a mix of ultramarine and Prussian blue. The base layer, which constitutes the sky, was extremely dilute. The foreground

sections were created by washing lemon yellow over the blues to form an interesting range of greens, and these were later detailed with defining strokes of blue and green representing stalks, leaves and buds. The vibrantly translucent petals of the poppy heads were made possible with four warm pink layers of thinned alizarin crimson. Folds, creases and surface detail were added with a small hoghair round brush (no. 4), using ultramarine blue.

The watery consistency of the Prussian blue oil floats over the green (a mix of lemon yellow and ultramarine blue). The loose, blob-like nature of the paint perfectly describes the shady canopy of the trees.

The merging of successive glazes casts a warm brown over the middle ground of the picture. This rich, stained earth colour harmonises with the overall palette because it is created from it. Little detail is necessary; the lack of information allows the poppy petals to be the focus.

The vivacious alizarin crimson petals, set against the ambient green field, spark up the strongest possible contrast – that of a colour complement. This device gives the illusion of heightened brightness.

TIP

Use artistic licence to alter composition, colour or tonal variation in a painting. Don't allow your working drawings to dictate the look of the final piece to such an extent that they inhibit the development of creative ideas.

Opaque and impasto

Applied direct from the tube, oil or acrylic paint has a dense, creamy texture that is opaque: it does not transmit light. Laying paint thickly, or impasto, gives artists the freedom to overlap colours and to raise paint marks over the surface. The results with either medium can be very exciting and evocative – consider the emotive energy displayed in van Gogh's last, turbulent landscapes.

Layering with acrylics

Undiluted acrylics can be layered easily. Unlike glazing, it is possible to totally cover a dark, flat colour with an equally flat lighter colour. The darker colour beneath will not show if the paint is applied undiluted, or 'opaque'. Although this can also be done when using the chalkier medium of gouache, the binder is not thick enough to allow any sculpting of the surface.

Layering with oil

Oil differs from acrylic because its opacity is dependent upon the amount of oil binding the pigment. Oil as opaque requires what is known as the 'fat-over-lean' approach. Fat refers to the greatest oil content, and lean the least, after it has been thinned down. To build up full opacity using layers, you must make sure that the amount of oil is steadily increased as the work progresses. If lean paint is worked over fat, it is most likely to crack as it dries.

TIP

Paint that is too oily is hard to manipulate as impasto. Squeeze your paint onto a paper towel and leave for a short time to soak up excess oil, before applying to the support.

Impasto

Acrylic and oil are very flexible and can capture the quality of most surfaces and textures. Impasto techniques demand the painter to be rapid and fresh in approach, avoiding the overuse of colour or too many layers, which can muddy a picture.

Planning is important. A simple charcoal sketch will help order the elements and range of tones. This is vital when using oil, as its longer drying time prevents the easy correction of mistakes by overlaying. Nonetheless, try to be spontaneous; it helps you develop a broader range of marks and be decisive. Acrylic is better than oil when you want to experiment with working quickly.

This Mediterranean park study was the ideal subject for building a picture using opaque and impasto techniques. The overall ambience of the piece was brushed in with successive thin glazes of 'high key' colours, and the sky was broadly washed in using a flat hoghair brush with a mix of cobalt blue and white. From the overall haze of coloured flecks emerged the basis for the shrubbery. The strong midday sun bleached out the surfaces, thereby creating strong contrasts. Where form might otherwise have been hard to distinguish and understand, the dark undersides of bushes and light, leafy tips helped to create the forms. The blue of the sky wash provided the perfect base for the foliage, softened and greened with further glazes of yellow ochre.

Foreground forms

Our minds make sense of images from the clues they provide. Solid impasto brushwork on the bushes nearest the steps helps to define the leaf shapes and direction of growth. By using a raised texture they have became almost three-dimensional. This approach was also used to describe the solidity and texture of the steps, this time a painting knife being dragged across the surface and the marks softened down with a finger and some thin colour washes. This approach would have failed in oil – the thin-over-thick method would definitely have caused cracking of the paint as the thicker oil layer dried.

The central focus and weightiest part of the study are the palm trees, displaying strong tonal and textural definition. After glazing, the thicker fronds were drawn out with light and dark impasto strokes.

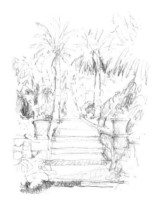

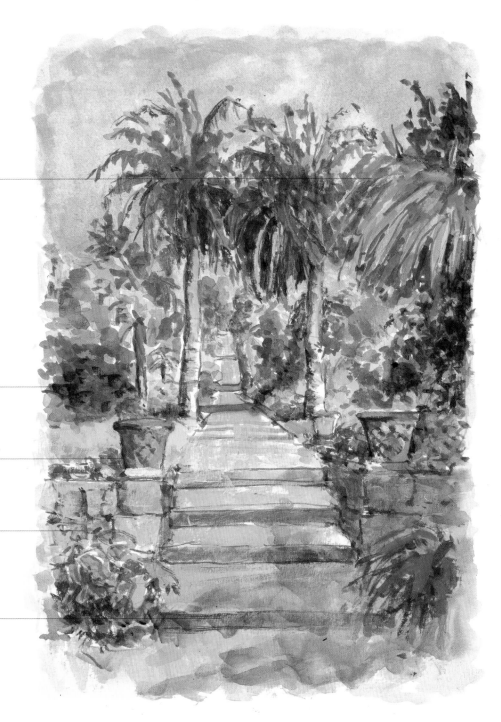

Palm fronds are defined with thickly applied paint laid over a cobalt blue and white sky.

A top layer of impasto flecks gives prominence to the low shrubbery in shade, adding depth to the picture.

Deep, purple-blue shadows define but do not dominate the delicate terracotta pots.

This area is a good example of solid impasto work overlaying thin washes.

A painting knife 'sliced' across the step front creates a well-defined edge.

Impasto for atmosphere

Spring in New York, and the brilliance of the early morning light prompted me to make a charcoal sketch, with a view to making a fuller, more considered painting from the drawn resource. When a subject unfolds before your eyes, it is important that you record it as best you can with whatever you have to hand. The dashing movements across the busy intersection were intriguing. New York's famous yellow taxicabs appeared to flash across the junction, as bright figures dressed in red and blue hopped hazardously in between passing vehicles. This constant series of small incidents, occurring every second, suggested a lively impasto approach to the oil painting.

Not letting the spirit of the moment pass is important. The charcoal sketch held it in black and white and fortunately I had a camera to record the surrounding colour and fall of light. The surface qualities of the various elements – broad, stone facades, bright atmospheric sky and faceless moving figures – suggested a broad, painterly treatment that oil thick from the tube could offer. This direct approach and the richness of oil colour describes the ambience well.

TIP

Impasto painting demands that the composition be worked up as a whole, and any specific detail should picked out after the completion of the main elements.

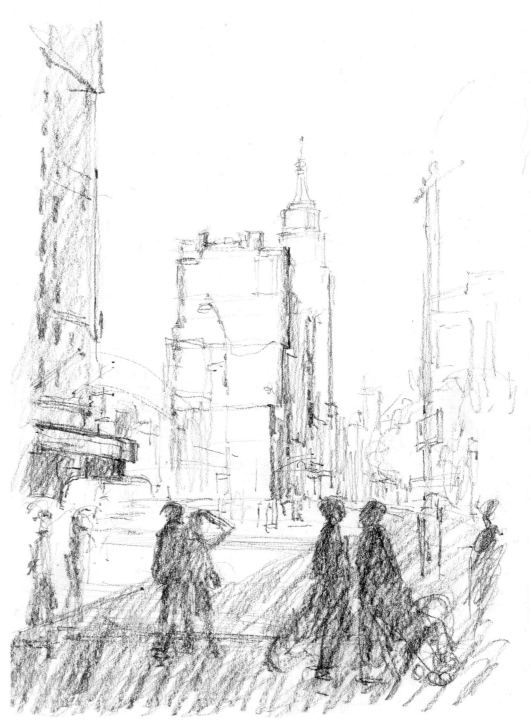

44

Thinner paint here (while still dense) indicates the lesser importance of this corner building. Broad brushstrokes and minimal detail direct emphasis onto the more elaborate surface treatment of the central gable-ended building and the activity at the junction.

Skies are rarely flat blue: wispy clouds can give a mottled texture, while reflected light illuminates the ground beneath with different intensities. Cobalt blue oil was squeezed onto the palette and thinned with turpentine before being scumbled across the canvas.

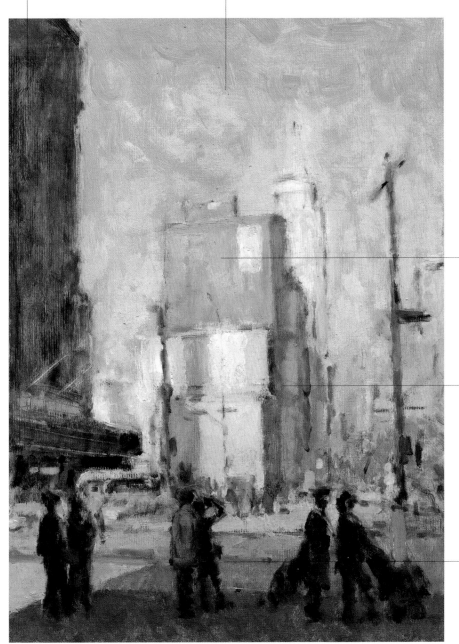

The yellow-ochre panel at the top storey of the building warms and contrasts with the sky. It is a key element, anchoring the composition.

The wall in part shadow emphasises three-dimensionality with its raised features. Paint application is deliberately choppy, with lifted edges and modelled windows.

A mix of Prussian blue, burnt umber and cadmium red helped to create the shadowy pedestrians, whose features are subtly sculpted by the subdued light falling on them. They are a vital device in the composition, their darkness helping to lead the viewer into the heart of the painting.

Underpainting and alla prima

Underpainting is the general term given to the first step in the making of an oil or acrylic picture. Having drawn the subject out onto paper or canvas with dry media – charcoal or pencil, or a fairly dry brush and paint – some artists like to take their preparation one stage further by underpainting in monochrome. This process involves planning the composition and assessing the tonal variations, in readiness for subsequent layers of colour.

TIP

When painting alla prima, make fast, decisive strokes, but do not use too many colours – they will leave your pictures looking dull and overworked.

The most common hues used for underpainting are sepia and earthy browns and reds, although this has changed over time. The Renaissance artists favoured greens and blues, onto which complementary skin tones were built in very dilute glazes. There is no set way to underpaint; techniques as wide-ranging as scumbling or washing wet-in-wet can be adapted into a personal approach.

Alla prima

Alla prima simply means 'at first' and refers to the rapid execution of a composition without underpainting, usually completed in a single session or sitting. Note that alla prima does not refer to any one technique of painting but is effectively delivered through fresh, deliberate strokes of wet-in-wet paint. Colours blend together with soft, blurring edges and definition is achieved optically where they contrast against one another in their value or tonal weighting.

A sensory response to their subject, and the desire to work out of doors, made the French Impressionists pioneer this new direction in painting during the latter years of the nineteenth century. Claude Monet, Camille Pissarro and Alfred Sisley, among other Impressionists, rejected tonal glazes and the studio method of laborious layering, in favour of direct brushwork from palette to canvas.

Alla prima preliminary sketch

Drawing always provides access into a new picture – an opportunity to analyse potential visual problems and begin the thinking process. Tonal values are important in alla prima painting. This sketch of a plant pot, vase of flowers and decanter helped me to assume a directional light source, here seen from above and to the right, and define it with a full scale of graded tones, stroked in charcoal.

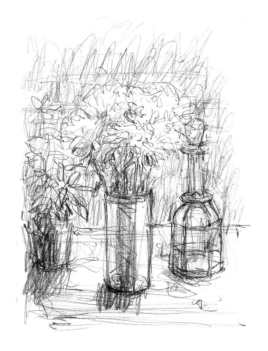

Alla prima artwork

Vibrant yellow blooms provided the source of inspiration for this study. It was executed in a single session with the object positioned in front of me. I worked with a basic palette of cobalt and Prussian blue, yellow ochre, cadmium red, burnt umber, sap green, and flake white. I used a range of medium-sized hoghair filberts and flats to create brisk, lively marks.

Here the intensity of yellow is broken where it is blended with warm, terracotta pink. The contrast defines the fullness of the flower-head shapes.

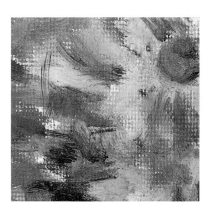

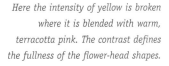

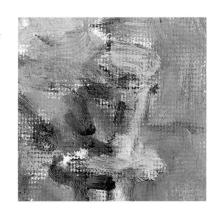

The thickened glass of the decanter is depicted with small, deft strokes of green, blue, and a little terracotta pink mixed from cadmium red, yellow ochre and white. Light reflects strongly onto the glass and is transmitted through its thick chunky mass as slabs of solid, breaking colour.

To create the shadowy base beneath the objects, burnt umber is spread across the blue with broad, directional strokes, both vertical and horizontal.

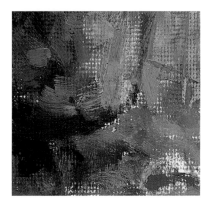

Knife painting

A painting knife should not be confused with the longer-bladed palette knife – a tool used for mixing pigments together on the palette. The painting knife resembles a builder's trowel in miniature, with a diamond-shaped blade and a cranked handle, which prevents the user's hand from spoiling the work. Additives such as gel medium for acrylic (see page 23) are now commonly used to add bulk to the paint and give it a firmer texture, and this can aid the knife-painting process.

There are two main types of stroke to consider when using a knife. The first is a broad, decisive stroke applied with the widest part of the blade that cleanly sets the paint into position. The second is a precise stroke under the guiding pressure of the index finger, perfect for manipulating and shaping the mark. You can also scratch into an existing paint layer using the tip of the blade.

To smooth and soften an area of wet colour, rest the heel of the knife on the support and drag it across with firm pressure, spreading the paint with it. Where the intention is to reveal the weave of the canvas or a colour beneath, tilt the knife at a slight angle to scrape some of the paint off. If you pat the paint, it will stipple. Scraping successive layers on top of each other when they are dry will produce a sharp-edged broken colour, ideal for architectural subjects. You can of course develop other blade techniques to suit your creative style.

A light underpainting in a thin, neutral colour is good preparation for knife painting as tones can be added and the main elements drawn in. Thick paint should be used straight from the tube and applied with the flexible blade of a painting knife, where it can be sculpted and carved using the different surfaces of the blade. Paint is best applied with the underside of the blade, in one firm stroke. This smooth surface reflects most light and sets a stable base onto which a variety of strokes can be added.

Greek doorway

Windows and doors are strongly symbolic to artists as they can allude to the basic human aspiration to freedom. A visit to Greece revealed a wealth of textural riches: doors and window frames, many set within rugged walls. The combination of patched, slatted doors and roughly plastered facades inspired this work in oil, undertaken with the knife.

This green door in afternoon light has been patched, worn and warped by its use over time. Knife painting was clearly the best technique to replicate the raised textures hewn from stone and the cast of the sun forming shadows in the small cracks.

Overall yellow-ochre oil underpainting to light the canvas, with burnt umber to sketch the door and its surround.

This area of Prussian blue showing the recess of the frame was simply an early layer that had not been covered.

Thinner scraped burnt umber tooled into position with the edge of a knife to denote cracks.

At intervals, burnt sienna was pulled into the thicker layers to warm them.

White was added to the mix and trowelled over the canvas in numerous directions with a broad blade.

The point of the blade was directed into the surface to scratch further cracks into the topmost layers of paint.

Long, vertical strokes of Prussian blue were pulled from top to bottom, and then layers of yellow ochre spread over these strokes, creating a warm green.

Courses of thicker yellow ochre built to create a solid-looking surface.

Cobalt blue with a hint of yellow ochre (producing a tinge of green) was energetically scumbled across the open space in the top third of the picture. To achieve this, the brush was wetted with a small dab of turpentine and the thinned paint worked lightly over the paper with a confident breadth of stroke. The sky turns green where blue crosses yellow ochre, helping to unify the two sections of the composition: the landscape to the surrounding light.

By introducing shrubbery as burnt-umber blots with a broad, flat no. 14 brush, darker forms were established into the composition. Placed on the left-hand side of the picture, these offer a focal point on the viewer's journey.

Lightness of touch throughout was essential. Creating a picture without ground or underpainting allowed the whiteness of paper to show through, keeping it clear, fresh and bright.

The final quick, dry, diagonal brush marks, made with a no. 10 hoghair filbert, represent the moving grass. Detail of plant structure was not necessary, as we automatically comprehend the representational intention of the marks.

Mixing techniques

Memory, and even photographs, are not always enough to evoke the mood of a particular place at a particular time. Painting, with its rich vocabulary of strokes and marks, physically engages the viewer in a full sensory activity. Although oil is often associated with a relaxed pace of working, it is ideal for a rapid sketch. The techniques of scumbling, dry-brush and thinned washes can all work together on the same sheet, alla prima.

This crop field was shimmering in a warm summer breeze. It was certainly not a still scene as I sat down to capture the 'spirit of place'. The gently rolling hills receding into the distance demanded long, sweeping strokes of a broad brush, but the erratically swaying grasses in the foreground invited shorter, drier flecks to describe their movement and texture. The activity in the sky – deep, brooding clouds painted with a cooler contrasting palette – expressed the breeziness of the day.

TIP

When painting landscapes, consider the proportion of sky to land mass, and devote two-thirds of the composition to interesting features. A wide, open sky with strong cloud forms and suffused light can enhance the mood of the day. Changing landscape shapes that step back into varied tonal nuances provide the illusion of depth.

Rolling hills are brushed across the paper with a no. 10 flat hoghair brush. The colours are cadmium yellow and yellow ochre The diluted paint is applied with a fairly dry brush.

Creating textures

Textural variety is the spice of a painter's life. The rich and creamy consistency of oil and acrylic lends itself superbly to textural techniques. The purpose of texture is sometimes literal description, but more often it has an expressive or decorative function. Experiment with brushmarks to add an extra dimension to your paintings.

Introducing a range of textures and techniques can enliven a composition and make it more interesting to the viewer. It will also stop you lapsing into habitual working methods. Try to use textures and brushmarks appropriate to the final effect you wish to achieve: some lend themselves to subjects where calm is required, while others create an energetic surface that produces a sense of turmoil. Simple techniques, well chosen, produce the most realistic effects.

The choice of which textures you want to employ in your oil and acrylic compositions will probably depend on the subject matter. A study of a rough wall or a pebble beach will need very different handling to that of a calm, meandering stream. It is not just varied brush or knifework that will render the subject correctly. Adding other materials to the paint, for example modelling paste or sand, can create the ideal texture to correctly describe an area of a painted scene. This can save you hours of painstaking work trying to replicate that texture with strokes and marks.

It is only through experimentation that you will make new discoveries about your media. Always consider the properties of the media you are using before mixing them. Any oil or wax-based substance will not work with acrylic paint because it is water-based. If you are choosing to etch into a thick oil crust, bear in mind that it could take weeks to fully dry. The extraordinarily tactile, cake-like surface of a painting by the modern British artist Frank Auerbach (b. 1931), with its multiple layers of thick paint, manipulated then scraped back, takes many months to dry. Artists who work in this way invariably have a number of canvases on the go at any one time. It is, however, worth pursuing other techniques because developing them will give your work an individual flavour.

It is worth learning traditional oil and acrylic techniques, but don't be bound by them. Dare to be inventive with your materials in order to develop new approaches to your subject matter.

Textured landscape

This rolling, midsummer landscape is an example of texture lending atmosphere to what might otherwise have been a fairly ordinary, traditionally rendered sketchbook study.

The sky was painted using the edge of an old credit card, working with cobalt blue and white on dampened paper. An extra wash of cobalt blue makes the sky darker and more moody.

Farm buildings impastoed with a painting knife. A thin band of cadmium red for the barn draws the eye to the middle third of the picture.

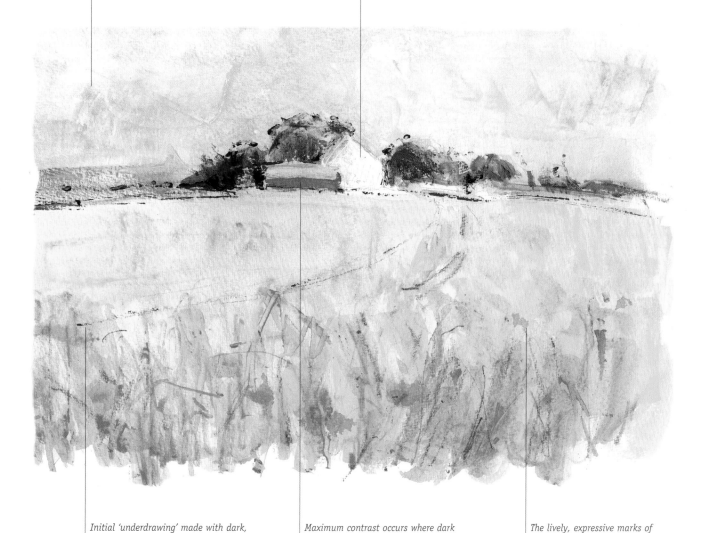

Initial 'underdrawing' made with dark, water-soluble pencil and sanguine chalk pencil.

Maximum contrast occurs where dark greens meet the strongly defined gable end of the house, creating a strong focal point.

The lively, expressive marks of cadmium red, representing poppies in the foreground, draw the eye to the upper part of the composition.

EXERCISE

Divide a sheet of oil-painting paper into 12 equally sized squares, with a generous gap between each. These are small 'frames' within which to explore brushmarks and textures. Try out the examples on these pages, then see if you can come up with some more. The results of your experiments will be tiny works of art in their own right, displaying the versatility of oil as a medium. The same techniques are possible with acrylic, though you may have to work faster as the paint dries quickly. Try experimenting with both media so that you can compare and contrast the results.

Wet-in-wet washes produce soft, hazy colour effects. Here, thinned acrylic paint was touched onto dampened paper and the colours allowed to bleed gently into one another. Keep the brush damp when using acrylic paint to prevent clogging the bristles and a build-up of unwanted paint around the ferrule.

Blending to produce smooth gradations of colour or tone is a traditional oil-painting technique. Use a series of short, smooth strokes to work one colour into the next. For best results, the paint should be fluid but not runny.

Underpainting is a useful way of creating an overall temperature or tone, and for setting up contrasts. After priming, a single or mixed colour wash is applied, here, thinned cadmium red. In places, the white ground of the support shows through, creating a pleasing luminosity.

Broken colour – small, irregular strokes applied without smoothing or blending – is an excellent means of capturing the fleeting effects of light on the landscape. Light handling of the brush enables the colours to touch and merge without going muddy.

Impasto is paint applied thickly enough to retain the marks and ridges left by the brush. Use it to 'sculpt' forms and mimic textures such as that of tree bark.

Painting direct by squeezing oil or acrylic paint from the tube onto the support is an exciting – though expensive – alternative to using brushes and knives. The paint is smooth but very thick, and heavily saturated colours can be squirted on top of one another without breaking the surface or merging.

Create **three-colour mixes** by squeezing a little paint from three tubes of a similar hue, and play a game of moving them around the paper, forming new colours and tones. You will find there are an amazing number of different combinations of just three colours.

This **knife blend** in two colours was created with a painting knife. A broad blade has been used to smear cadmium red onto the paper, followed by an overlapping spread of cadmium yellow. A raised crease marks the point where the two colours were blended and the pressure on the knife released.

Knife impasto is the term given to the raised surface created when the blade of the painting knife is used to form a protruding edge that lifts the pigment. The white marks are caused by the blade completely removing all pigment as it cuts through the surface.

Using **mixed knife work** the blade of the knife is twisted and turned first in one direction and then another. As it is pulled around, there is great scope for creating regular surface patterns. This lively surface comprises burnt sienna, yellow ochre and white.

Sealed colour can be created by sealing conté chalk or pastel pencil under a veil of thinned acrylic colour, giving it a ghostly quality. This effect that can be increased with successive glazes.

Printing from plastic sheeting *is an innovative technique that creates attractive, mottled patterns. An image can be built up in layers using this method, and the paper used to print onto can either be dry or slightly dampened to allow a greater spread of the paint across the paper surface.*

Wet glazes with sgraffito. *Apply a wash of colour and allow it to dry. Apply a second wash, in a different colour; while this is still wet, scratch into it with the end of brush handle to expose the dried underlayer. This technique is called sgraffito.*

Runbacks *are possible if a medium is sufficiently fluid. Making paint run can be enjoyable to experiment with, though you have little control over the medium's course. Unlike watercolour or dilute acrylic, when oil is left to run it does not merge with the adjacent colours.*

Incised marks. *These textures were scratched into a thick layer of yellow ochre acrylic mixed with matt gel medium. On the left, the stippled marks were made with the tip of a painting knife. On the right, the paint was wiped back with a soft cloth so that the grain of the panel showed through and the end of a brush handle was used as a drawing implement.*

Mixing sand with paint. *Almost any granular material can be mixed with oil or acrylic paint to create a textured surface. Here, building sand has been mixed with acrylic paint to give it a grainy texture. The paint should be of a thick consistency, but not too dry.*

Sand and sgraffito. *Marks can be etched into wet, sand-textured paint with a knife, stick, or any sharp implement to create an even more rugged surface. Note how the ridges of the paint cast interesting shadows, creating a bas-relief effect.*

A simple subject reproduced employing a well-chosen selection of textures and techniques can create a complex and interesting painting.

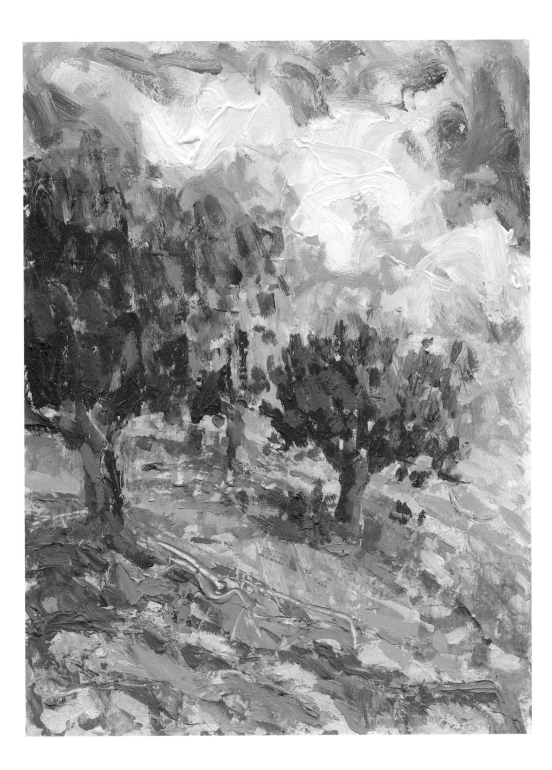

Wax resist

Wax resist is an easy, clean technique for creating broken textures in an acrylic or mixed-media painting. Plain or coloured wax can be applied using a crayon or candle. It is a good alternative to lifting out or scraping away paint, and is ideal for suggesting reflected light. This technique is also useful when you want to represent uneven surface patterns such as stone walls, fascias of buildings, tree bark, and roads and pathways.

Based on the simple fact that water and grease repel, a dilute acrylic wash dropped onto an area of drawn wax simply runs off, soaking into untreated sections of the support. Because the wax is quite hard, it does not crumble fully into the weave of a canvas or canvas panel, nor does it rest in the dips of grained paper, so the texture of the support is made visible through the resist. If required, it is possible to lay thicker passages of acrylic over an area of wax resist so that the wax does not show through.

This drawing is a mixed-media study with a predominance of wax resist providing the grainy textures. Heavily diluted acrylic paint has been applied in thin watercolour-like washes. As such, this is technically a tinted drawing as opposed to a painting, and with its ink keyline defining areas of detail, the technique is commonly known as line and wash. The added wax resist lends a feeling of realism, and the uneven covering of pigment gives the image a liveliness where otherwise it might have looked flat.

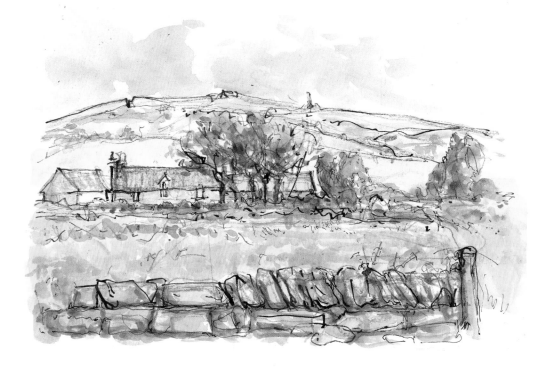

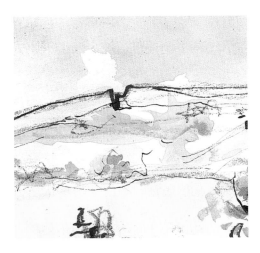

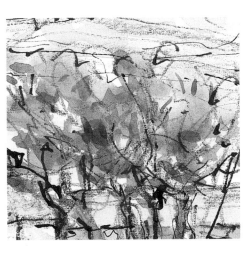

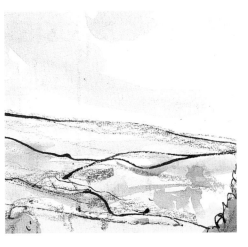

As the hills recede into the distance, colours become paler and objects flatter. Flowing lines of candle wax follow the hillside curves, and the resist ensures that these areas remain the palest.

Flecks made with the pointed end of a wax crayon represent masses of foliage. They are more prevalent on the top of the tree where daylight falls most consistently.

The land and sky are closely related in tone and the use of resist follows through both.

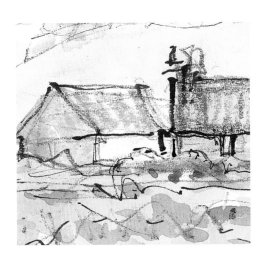

The thatch of the cottage has a strong vertical pattern, created with controlled crayon strokes.

The broad edge of a wax candle has been used to fill in the boulder shapes that are drawn with ink.

A white wax crayon has been randomly scribbled across the field to denote the soft, undulating texture of grass.

Broken colour

Attaining the full colour potential of paint depends on the transmission of light through thin glazes, or reflecting off small gaps where pigment misses the surface of the underlying support. To achieve this, you can adopt the technique known as broken colour. This involves mixing strokes of colour on the painting surface – the maximum vibrancy occurring where strong colour contrasts meet.

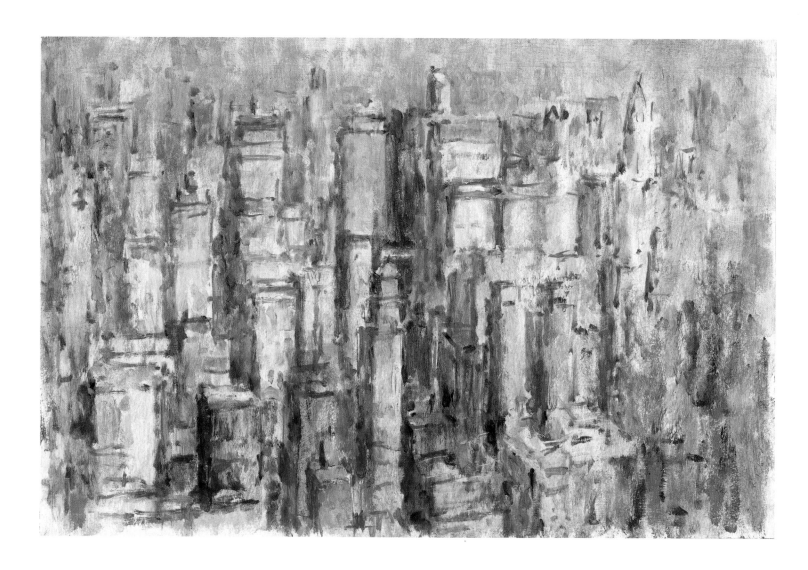

Optical mixing

The Impressionists were the first French painters to capture the ebullience of southern Mediterranean light using broken colour. To achieve their startling effects, they dabbed pure colour onto the canvas without any blending or mixing. When viewed from a distance, the eye blends the two colours, which merge into a third colour. This 'optical mixing' or 'broken colour' technique is widely used in both oil and acrylic painting. The pigment can be brushed on wet or dry, and with a whole variety of strokes, flecks and sweeps of the brush.

Early morning city skyline

Where the French painters had recorded the heat of the sun with the searing hues of a primary palette, many northern European painters described the muted qualities of the northerly light with a more sober style. The prolific output of German painter Oskar Kokoschka (1886–1980) made him one of the catalysts of a new Expressionist genre. He chose to make his images using a more subtle, harmonious tonal palette, without in any way compromising his violent, raw, painterly edge.

This city skyline echoes Kokoschka's palette. The harmonies of broken oil colour painted with broad-edged, hoghair flats and filberts, in subtle pinks, violets, greenish-greys, muted blues and pearl whites all suggest an early morning mist that cloaks the imposing skyscrapers.

The white of an unprimed canvas shows through clearly where the colour breaks. Broad stripes of viridian green, violet, yellow ochre and ultramarine blue all merge to form a brightening, bluish-grey.

The white of the canvas is left bare where the strengthening, directional light source bleaches the facades of the tower blocks. Dry, vertical strokes of yellow ochre and ultramarine blue are pulled downward over the white canvas to add warmth and surface texture to the buildings.

The most detailed part of the image lies at its very heart. Although understated, there is less breaking up of colour here and the thick passages of violet and blue are worked closely together on the canvas, with little white showing through.

The brushmarks are deliberately created in varying lengths and directions, to lend the scene plenty of life and prevent it from becoming stilted.

Sgraffito

Using any rigid instrument, such as a paintbrush handle, a knife, the edge of an old credit card, or simply your fingernail, the surface layer of wet paint can be scratched into to reveal the layer or layers of dry colour beneath. Dry paint can also be scratched into with a sharp point such as a knife or razor blade to create finer lines. Highlights and textures can be subtly suggested in this way. The technique is called *sgraffito*, derived from the Italian *graffiare*, 'to scratch'.

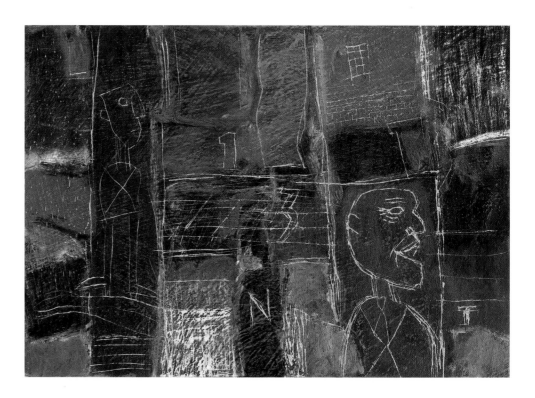

After Dubuffet

Removing selected areas from multiple layers of paint can produce exciting results, as the colours of the underlayers glow through the top layer. In search of the untarnished creativity of the amateur – and the insane – the French painter, Jean Dubuffet (1901–85), became obsessed with the graffiti he saw daubed across the walls of the poorer quarters of Paris. His attempts at emulating this art brut (raw art) involved building up several layers of dense oil texture, scratching through to the earlier colours, and then finishing off with fresh drips and splodges of surface mark. The naïve, child-like drawings he produced are alive with the energy of the painted surface.

Soft tones *Repeated scratching away of pigment creates broad areas of tone which are softer than the single lines made with the point of a blade.*

Zig-zag lines *By scratching into a thin layer of dry paint, sharp lines are produced which reveal the white of the support. The thin edge of a painting knife made these extraordinarily fine grooves in the image. It is a type of sgraffitti but with less density in the paint layer.*

Hatched lines *A regular pattern of equally spaced, scraped horizontal stripes creates the effect of an evenly balanced tone.*

Rubbing with sandpaper *on dry paint creates a broken texture ideal for representing weathered surfaces.*

Subtle effects *This ghostly quality was again created with the blade, dragging it across the panel at 45 degrees. The brighter the white showing through, the more burnt umber has been scratched away.*

Revealing colour *Swatches of oil colour were painted onto the board before darker, burnt-umber glazes were applied. When dry, they were gently scraped with a craft knife, revealing soft, glowing colour.*

Oil-paint sticks

Oil-paint sticks retain the full richness of their traditional stable-mate, allied to an ease of use that could revolutionize your sketching. They are small and convenient to carry, have the appearance of pastel, dry in half the time of oil, and remain workable for several hours after initial application. As a relatively recent development, oil-paint sticks have bridged the gap between oil pastel and the full-bodied experience of studio oil painting. Combining pure pigment with highly refined drying oils and a wax binder, they can be used either as a drawing or painting medium, applied with a knife, brush or simply direct strokes from the hand-held stick.

Versatile and convenient

The great advantage oil sticks have over tube oil is their convenience, combined with a flexible formula that allows them to be used on primed or unprimed canvas, hardboard and a variety of different fabrics and papers. This quick study of a beach scene demonstrates their versatility.

To blend the marks made with a stick, it is probably easiest to use a finger – though brushes and knifes will produce a different effect. A special transparent blending medium is available to assist the technique and to give extra gloss to the colours. Turpentine or white spirit can be added to increase fluidity. Dipping the end of the stick into the spirit will 'melt' it, producing a streaky, broken mark – perfect for drawing in a painterly style.

TIP

When not in use, oil-paint sticks dry at the tip, forming a skin that seals the pigment into the plastic wrapper.

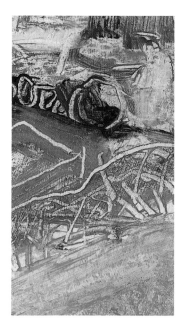

TIP

Drying time varies according to humidity and temperature. Never use oil-paint sticks for underpainting if tube oil is to be laid on top! The former has more elastic properties that could cause the upper layer of oil paint to crack.

Sgraffitto is used here to bring detail to some of the equipment associated with the life and work of fishermen. The outlines of the fish boxes have been scratched out of thickly applied pigment.

Thinned with turpentine, the colour for the sky is gently washed in with a flat hoghair brush.

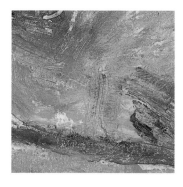

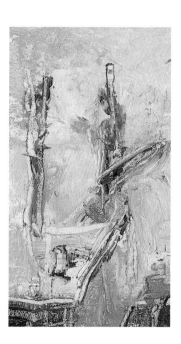

Cadmium yellow and cadmium red are blended together with the finger and a hoghair brush.

Here the surface is heavily drawn using a technique most commonly employed with oil pastel work.

The tip of an oil-paint stick was dipped into turpentine and the masts drawn directly from the stick, giving a broken, wet-into-dry mark.

Monoprinting

If you're feeling uninspired and looking for something to get your creative juices flowing, try making a monoprint. It's quick and easy, and offers a complete vocabulary of textures, stains, strokes and translucent colour layers that will fire your imagination.

Monoprinting combines both painting and simple printing techniques. A basic monotype is made by painting onto one half of a sheet of paper, then folding it in two and printing the image onto the blank half. More often, an image is painted onto a non-porous surface such as glass, metal or Perspex. It is then transferred onto a sheet of paper by laying the paper over the slab and rubbing it down with the hand, a roller or the back of a spoon. Oil paint is best for this process as its slow drying time allows you to work into the image, but acrylic mixed with medium can also be used.

Another method is to cover the whole slab with a thin, even layer of paint, place the paper on top and make a drawing with a pencil or other sharp implement on the back of the paper: only the drawn lines will print (though accidental smudges sometimes occur, which can be incorporated into the image). Alternatively, the image can be drawn directly in the rolled-out paint. This will produce a negative print, as the drawn marks will be white. The finished monoprint can, if you wish, be worked into with more paint, or with a drawing medium such as oil pastel, to add an extra dimension.

This little monoprint, made in minutes, captures the essence of a landscape suffused in the light of a fiery sunset.

TIP

You can print as many layers as you wish, but if you use more than three superimposed colours the paint may begin to appear dull.

Sunlit arches

A Perspex sheet was used as the plate for this series of prints. Other print forms influenced the method used here: layers were built up by printing colours separately, a technique exploited in lithography and silkscreen.

Based on a simple classical arch taken from a quick sketch made in Greece, this print features clean, hard-edged curves as the central focus. The contrasting free, painterly quality of the transferred strokes of background colour is an attractive feature of monoprints, and I wanted this quality in the finished image.

The arches were drawn onto thin card and cut out as stencils. These were positioned on the plate and thick blue oil paint brushed liberally over the plate and around the edges of the stencils. A sheet of dampened cartridge paper was laid over the plate and even pressure applied to assist the transfer of paint to paper.

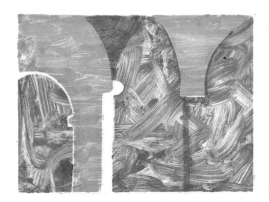

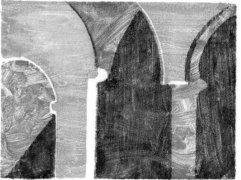

The stencils were carefully removed, leaving clean-edged white shapes. Next, the stencils were 'inked-up' with yellow ochre paint, evenly applied with a roller to produce a smooth film of colour, then aligned with the spaces on the paper and pressed firmly to print the second colour.

Cutting the stencil so that it is a fraction smaller than the original leaves a thin sliver of unprinted paper, giving the arch a three-dimensional quality. Another stencil was cut out and inked in red. When this was printed onto the right-hand side of the composition it partially mixed with the blue underlayer.

The residue of paint left on the plate forms a 'ghost' image. It is normally wet enough to take just one more (paler) print – so the term monoprint is not strictly accurate!

Mixed media

It is exciting to break away from the traditional use of oil and acrylic and broaden the scope with the addition of other dry and wet media. Mixed media, as it is collectively known, embraces almost any material compatible with either oil or acrylic. Making marks on a surface need not be constrained to pigment or pencils: for a contrasting textural layer, colour can be laid as thin 'glazes' using tissue paper painted with acrylic or oil.

Practice the mixed-media variations shown on these pages, then invent and develop your own on double-page spreads of a sketchbook as a handy future guide. When two or more materials are combined, the contrasts between their individual properties can be such that one medium can appear to float on top of another. Try to achieve this in your swatches. The resulting combinations are often interesting in their own right, but give meaning to a composition when they are employed to describe particular surface qualities or textures. Versatility is essential when creating mixed-media images. This means acrylic is the ideal foundation into which other media can be mixed, as it is thick and slightly tacky, but dries rapidly to a tough elastic film. Oil does not work nearly as well, limited as it is by the inflexibility of an oil base.

Hatched lines of coloured pencil with patterned tissue paper pasted on top.

Delicate coloured-pencil marks overlaid with solid areas of acrylic paint to create interesting textural contrasts.

Bands of roughly torn paper, pasted into position, with bands of slightly thinned acrylic applied in the opposing direction, so that the paper shows through.

Tissue paper, stained and manipulated with acrylic.

Partially glued, heavier paper with paint applied as though threading through the paper.

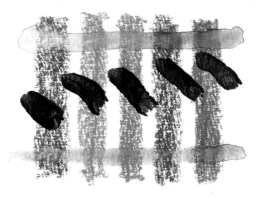

Stripes of partially diluted water-soluble pencil, with juicy flecks of acrylic dabbed across them.

Explore pattern with an interplay of torn paper and acrylic paint.

Wax crayon overlaid with acrylic diluted to the consistency of watercolour to produce a resist.

Thick strokes of acrylic buttered onto the surface with strips of torn paper pushed into the paint to create a 'glow' effect through the paper.

Frottage-style rubbing over a textured surface with a wax crayon, and then passages of thicker acrylic dragged over this surface.

String stuck to the surface with PVA glue, then acrylic paint added over the top.

Heavy acrylic impasto scraped over wet-in-wet blooms of diluted colour.

PEPPER
PEBER
PFEFFER
PEPPAR
PEPE
POIVRE
PIMIENTA
الفلفل

An aid to expression

The more you use mixed-media techniques, the more you will realize their potential. The use of varied and interesting materials or objects to make marks can enhance your image-making and suggest themes to develop. Some materials can even be pasted directly onto a painting as a substitute for the object being described. A textured piece of cardboard, for example, may represent wood grain perfectly, where trying to paint it would produce something less convincing. The ways in which different types of paint and other materials overlap and interact are central to creating mixed-media pictures, and the result is always exciting and surprising.

Mixed media composition with fish and lemons

No staring at blank canvases, wondering what to paint – this picture was started with a simple strip of brown cardboard box with printed type, glued in position in the bottom left-hand corner. Above, under, and around this, colour panels were created – shaped pieces in an interlocking puzzle. Their hues of solid blues and reds created an attractive visual chemistry when matched to the black, elongated shapes of the type.

The spotted tissue paper inspired the theme of a kitchen still life. Its regular pattern was purposely stuck over half of the picture surface in order to use the white tissue base for further layering. The thin-colour washes and coloured pencil strokes helped to soften the stark whiteness of the paper and integrate it into the block-based composition.

The body of the fish was cut from paper that had been printed to resemble the pattern of fish scales: watery, cobalt-blue acrylic was crudely brushed over a sheet of plastic, producing a wet, bubbly surface, which in turn had a blank sheet of paper pressed onto it. The blue bubbles transferred perfectly, making ideal scales for the fish.

Translucent washes of cadmium yellow allowed the spots to show through the skin of the lemons, but the Prussian blue shadows beneath the fruit shapes give them the appearance of three-dimensionality. The salt and pepper mills were delineated around printed lists, in different languages, of the words salt and pepper.

Troubleshooting

After having mastered the complexities of acrylic and oil colour, and the preparation necessary for both to work successfully on the support, there are still times when things don't go quite to plan. It is good to consider shortfalls in a positive light: sometimes they can be seen as a new and unconventional technique, having provided that necessary texture that you were struggling to create by conventional means. Failing that, you will at least have discovered more about your materials.

Accomplished painters and even professionals are occasionally flummoxed by irregularities in the behaviour of their materials. It is like cooking: getting the correct balance in the recipe is vital, too little or too much of the smallest ingredient can lead to a culinary disaster.

Follow the guidelines, and if you should happen to misjudge quantities, and the preparation is not completely successful, it can always be salvaged, at least in part.

Oil cracking

You have primed and sealed your canvas, and added a drying agent to thick layers of impasto oil, hoping to reduce the time it takes to dry. But you find that the oils are dried out by the volume of agent that you originally added and the paint cracks. Do not panic. Provided that it has adhered properly to the primed surface, it should remain quite stable on the canvas.

The network of hairline cracks (known as craquelure) can indeed be of advantage, giving your painting the aged look of an old master. It is not just with thick paint that this can occur. If your oils are excessively diluted, the over thinning may result in underbound paint that cracks and flakes. To prevent it falling off, use a flexible sealant or varnish suitable for oil paint. If the painting has a number of layers, this can look very effective as an alternative to broken colour.

Another way to create the craquelure effect, is to reverse the 'fat-over-lean' process so that paint is applied 'lean-over-fat'. The lack of flexibility in the upper paint layers causes them to crack, and this effect can be successfully sealed using layers of varnish.

Patching acrylic

Acrylic is very flexible, so the chances of it cracking are remote, but because it is so quick drying with superb adhering qualities, it can be difficult to correct mistakes. Usually, painting straight over the top is sufficient for correction, but if you have created an impastoed surface, the textural quality of the altered area may no longer be in keeping with the rest of the painting. In this case, you will need to cut the area out and replace it. The great thing about re-pasting with acrylic is that you can fill with thickened paint to the extent that joins cannot be seen.

You may decide that you have made a mistake in an acrylic painting once it has dried. First, try painting over the mistake. Unfortunately this does not always solve the problem because the previous shape or texture may still show through.

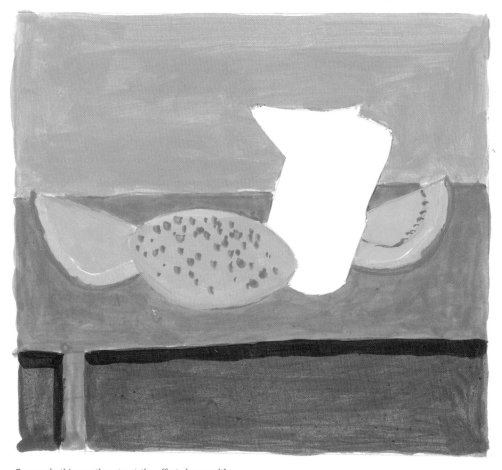

To remedy this, neatly cut out the affected area with a scalpel, taking care not to let the scalpel slip or cut into unaffected areas.

Paste a fresh, unpainted patch of paper or board back into the space that is left. Affix this shape from behind using a high-tack masking tape. You can now rework.

Scraping back oil paint

The beauty of oil paint is that it dries slowly, so if you are unhappy with a particular passage – or the complete painting – it is easy to scrape away the paint using a palette knife. Then wipe the area with a rag soaked in turpentine and it is ready to be painted over.

View mistakes as opportunities to develop a new technique that will bring depth and originality to your compositions.

It may be difficult to scrub away all the colour. If this happens, make a feature of the scraped paint as the basis of a revised work.

Lay new heavy base layers of colour onto the scraped areas; some interesting contrasts and mixes may occur.

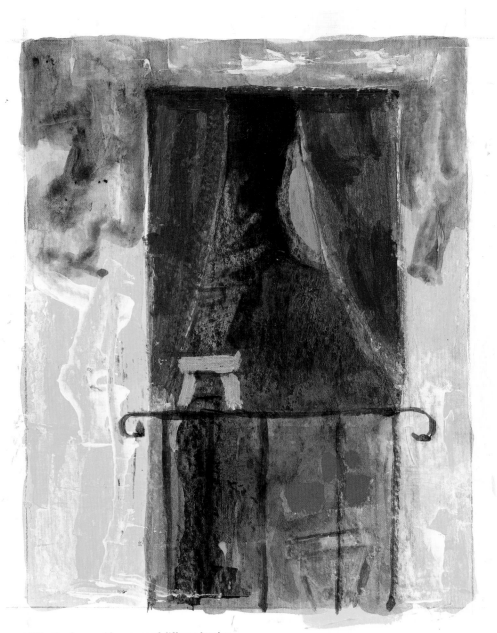

Add further layers with a range of different brushes and mark makers that allow the scraped textures to show through.

Making pictures

Ordering your studio space

A space to paint in that is free from domestic routine and interruptions is essential. Not everyone is fortunate enough to have a large, naturally lit studio or room. However, it is not a necessity provided that your space is comfortable to work in, well lit, and most importantly, well organized. Storing your tools, paints and other accessories properly will enable you to work methodically and efficiently. If you are fortunate enough to have a designated room as your studio, then it is important to consider how and where you store your work, to keep it clean, free of extreme atmospheric changes and in some sort of order.

Storing drawing equipment and brushes

Keep like materials together and away from those that are incompatible. For example, charcoal resting against pencils will blacken the pencil shafts, which in turn will dirty your fingers and everything you touch. Put charcoal sticks together in a small, lidded box to prevent them from breaking. Pastels are most effectively stored in a container of dry rice, which separates them and prevents colour contamination. Assorted pens and pencils are most conveniently kept upright in jars and pots where you can easily distinguish them and select colours. Brushes must never be stored full of paint or resting on the bristle end, as this will permanently misshape them. After use, rinse them thoroughly in water or turps, wipe with a rag, then gently clean the bristles with mild soap and warm running water. After a final rinse in clean water, leave to dry in a jar, heads upward.

Paint storage

Classification of paint is a personal matter. I have a friend who lays out her paint tubes according to hue and tonal value. It is an impressive sight, but most importantly, it suits her clean, methodical way of working. The late renowned British painter, Francis Bacon (1909–92) owned a studio in apparent chaos, with brushes, rags and tubes discarded in heaps on every surface and completely covering the floor so that it could not be seen. However, his dramatically raw, energetic canvases were brought into order through the disciplined restraint of the painting process. Nonetheless, it is best to store paint tubes away in tins or drawers when they are not being used and only have to hand those that you need.

TIP

Always be sure to secure paint caps immediately after use. If the screw thread on a tube gets clogged, remove excess paint by running it under hot water. This will ensure that the cap forms the correct seal when you screw it back on.

Storing paper

An architect's plan chest is the ideal storage for papers, but these are expensive and require a lot of floor space. Failing this, use a dry, dust-free place, where paper can be laid flat, away from direct light – a cupboard is ideal. Remember that dampness can cause paper to buckle and render it unusable. Watercolour paper is especially susceptible to damp, which activates impurities in the paper. These show up as brownish spots that will not take colour.

Storing canvases and panels

Dampness can warp canvases and wooden painting panels. Store them upright in a dry place. Batons of 50 mm x 25 mm (2 in x 1 in) softwood can be used to make a simple storage rack. A freestanding clotheshorse or an old wine rack make excellent drying racks for paintings.

Lighting

Correct lighting is vital for painters. True colour matching is impossible unless you have a natural or simulated natural light-source. Light should be constant, without variation caused by bright sunlight and strong shadows. Even light is best: this comes from a north-facing direction in the northern hemisphere, south-facing in the southern hemisphere. Where a sunny room is the only option, light can be corrected by hanging thin, cotton net curtains or fine gauze over the window. Daylight simulation bulbs or fluorescent tubes are an excellent source of near-natural light for working after dark. They are distinguished by their clear, blue glass and fit all standard lighting equipment.

Planning a work

It is rare to just sit down and spontaneously achieve a good result – even for the most experienced artist. Your work will best develop by working through set tasks matched to appropriate techniques. Paintings should have an intention, be thoughtfully planned, then refined by the process of working. Proceed logically and sequentially, solving visual problems and pulling together loose ends as you go. Your final piece should realize your aims and become stronger as it progresses.

Sketching and photography

Direct recording is an essential part of planning for a painting. Where possible, begin with rapid sketches to familiarize yourself with the scene. When you do not have the time, or bad weather does not allow this, use a camera. A snapshot will firmly underpin any energetic first scribbles. Use double-page sketchbook spreads for exploring marks and assisting the flow and formulation of ideas. Never rely on the colours of photography: note colours down as you observe them at the scene.

My sketches of a local market reveal various thoughts and help to plan the final observational painting. The painting was a deliberately vigorous account of the experience in keeping with the spirit of the early sketches.

Begin by looking for interesting activity. In this sketch I was drawn to the animated gestures of a small crowd around a flower stall. My non-waterproof, fineliner pen nervously worked its way across the paper, plotting and joining points as it went, eventually focusing on the figures just to the left-of-centre. They were given tonal weight through the addition of a light wash of water, which caused the line to run and bleed as a diluted ink tone. Little peripheral detail is necessary – there is barely enough of a squiggle to indicate flowers and stalls in the background, but our minds are very good at approximating what is missing.

The first of a sequence of quick compositional studies in pencil and acrylic helped me to work out the balance of tones and colours. I decided to keep a cool, diluted palette to retain the spontaneous feeling of the first ink sketch. Strongest colour was reserved for the central characters, followed by muted hues to denote context.

Further interest in the decorative stripes of the stall canopies led to this development. Their structure contrasted successfully against the looser, more organic bay trees, which in turn contrasted against the pose of the bending figure, selecting flowers.

The scale and sense of isolation of the figure of a woman in a red hat and scarf work particularly well against the background activity, loosely suggested in broad strokes of yellow, ochre, and blue-grey acrylic. The contrast of scale gives the scene a greater spatial depth.

For the final piece, I developed as the principal theme the device of the scaled-up figure from the previous sketch, but added greater detail and more controlled use of colour in the background shoppers. The feeling of perpetual movement was captured through the traction of limbs and long, directional shadows trailing behind. The staggered placement of moving people also helped to create the illusion of movement and established a strong, off-centre focal point.

Getting started

You will have to make compromises in order to begin, so do not expect too much – match your present skills with achievable goals. A masterpiece may be a distant dream, but a well-planned painting of an interesting image, showing sensitive handling of colour and form, will give you a sound foundation from which to begin. Great artists do not create on inspiration and talent alone; like everyone else, they are rewarded by a combination of factors, most important being honing and maintaining their skills. Start by working on the techniques discussed earlier in this book.

Set aside a time every day or week to work on your exercises. These are fundamental to your development; they are to you what scales are to a musician. Good technique is important but not just for its own sake – by gaining strong painting skills you can quickly move on to cultivating a personal approach. By practising for just 30 minutes a day, you will learn and achieve more in a surprisingly short time! Consistency is the key, for the amateur and professional alike. Being able to communicate your creative thoughts competently with appropriate use of materials is very liberating. The sense of satisfaction you will feel in your achievement should be a major boost to your confidence. Don't wait for the perfect painting day; it may never come. Good weather, consistent light and strong compositional elements rarely occur in one place at one time.

Choose a simple subject

I chose this subject for its startling simplicity. First, having set up a portable easel and drawing board, I spent about ten minutes just looking, assessing and deciding how I should reproduce the scene before me. The natural shape for painting landscape is the wider 'landscape' rectangle, but I wanted to feature the gorgeous, shimmering shrub with its rich, red brilliance, and decided that I could best do so in the upright 'portrait' format.

To establish how the composition would work, I made a rapid working sketch with charcoal on cartridge paper. The bush would carry the greater depth and 'weighting' beneath its shadowy branches, leaving the top two thirds for much lighter, airy brushwork.

Next, I drew the main features with a dry mix of burnt umber and phthalo blue oil (sepia is a good ready mixed alternative), using a no. 8 hog-hair filbert on the pre-primed canvas board.

Filling in was done partly on site, and finished later the same day in the studio. The sky was scumbled and brushed loosely using thinned cobalt blue and white. The white clouds were lifted out of the wet paint with a soft, clean rag. The bulk of the picture consists of the dry, stubbly, grass field. I made short, dabbing strokes with yellow ochre, adding hints of cadmium red in places, following the undulating lie of the land. The bush was built of successive layers of short flecks of cadmium red, with violet and Prussian blue creating the deep shadows. A final touch were the rooks, hauntingly reminiscent of van Gogh's last paintings, and these rhythmical marks added the movement and texture necessary to draw out the life in the scene.

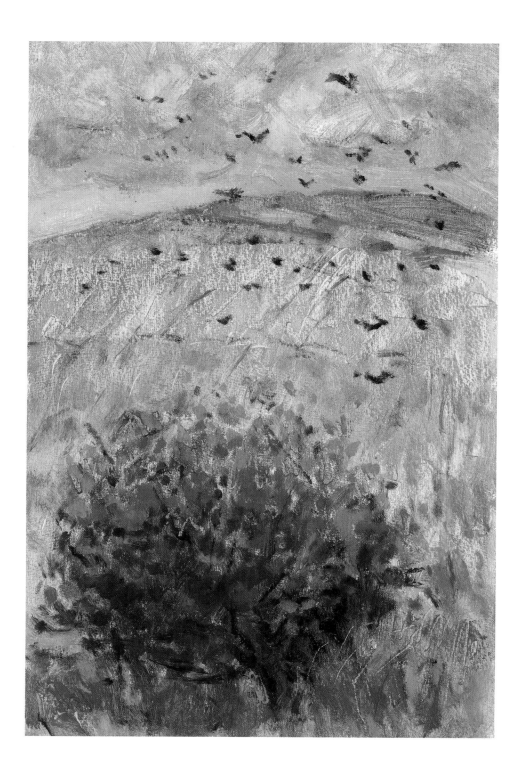

Composition and balance

The art of arranging forms, shapes and colours within the pictorial space is known as composition. There are no strict rules concerning the placing of these elements; intuition plays a large part in the process. We sense what is appropriately placed within a space; equally, we are acutely aware when something is inappropriately positioned.

Good composition establishes the correct relationship between various elements in order to convey an intended meaning. To create an eye-catching composition, shapes, forms and colours should all work together in a dynamic way and hold a viewer's attention. A strong colour in one part of the picture might look imbalanced, but when it is counterbalanced by a prominent shape elsewhere, balance is restored. Compositional order gives a sense of equilibrium, but exact symmetry can appear lifeless. A picture that has two equal halves, though technically acceptable, can be quite dull. A useful rule is to divide images into thirds. These areas or 'planes' tend to work best when they are unequally divided – but remember that an element that occupies two-thirds of a picture will naturally appear to dominate. However, rules in painting are for guidance only: in the hands of a skilled artist, an object placed in the centre of a picture may be at its most effective, and a horizon cutting across the middle of a landscape may work well.

This central horizon line, where the two background colours meet, demands the creative placement of other elements. The centred milk jug is balanced but rather predictable; it is only the positioning of the three balls that upsets the symmetry. The red ball standing alone on the left draws attention away from the centre of the picture, creating visual tension between the two areas.

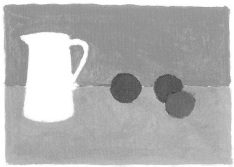

When the jug is moved to the far left of the picture, it grabs the focus and initiates the division of the picture into thirds. To counterbalance this emphasis, the three balls are moved to the centre-right of the composition. Even here a 'sub-narrative' is established – the shift of a red ball away from the group in turn demands our attention because it creates an asymmetrical grouping.

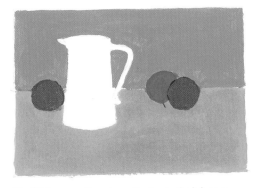

The third composition places the jug to the left once again, but moving it from the edge of the picture makes the composition less risky, more balanced. The jug and a red ball couple up, near to the red and green balls that overlap on the right, thereby focusing the dynamic tension within the rectangular area.

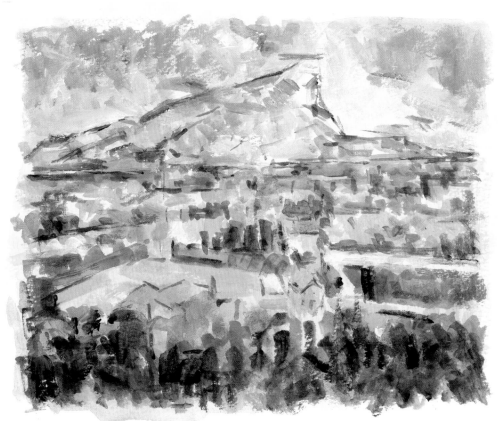

After Cézanne

Often referred to as the father of modern painting, Paul Cézanne (1839–1906) was obsessed by the structure of pictures, and by his favourite Provençal view in particular. His fascination was to probe beneath the surface attributes of colour and tone to subtly expose underlying forms and their structure, as they existed in nature. His method for doing so was the precursor to Cubism, and his brushstrokes all follow the forms of trees, or buildings, which lead the eye to further depths and vanishing points beyond the canvas. As this abridgement of his 'Mont Saint-Victoire' shows, Cézanne's simple palette of greens, blues and yellows is used to engage the theory of 'aerial perspective': as the detail recedes, it breaks down into paler, bluer strokes, creating the illusion of distance. The composition is strongly banded into horizontal sections, and the white roads create natural dividers for the complex pattern of diagonals and horizontals, counterbalanced by the spirited, blended vertical strokes of a broad, flat brush.

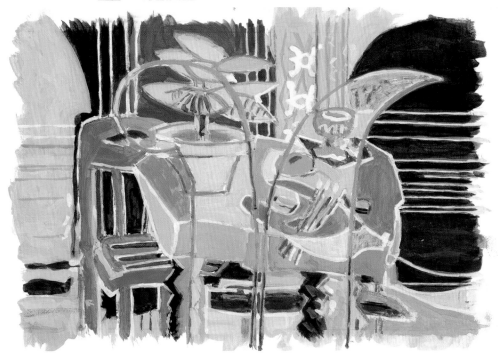

After Braque

The masterful painting 'Large Interior With Palette' by the Cubist Georges Braque (1882–1963) is a comprehensive and distinct example of superb composition. It exemplifies the realization of Braque's aim of depicting movement within and around a composition. As the précis (left) hints at, this was successfully achieved through the overlap of forms and overall use of a limited, muted palette. Layers of overlap and 'pictures within pictures' challenge the accepted understanding of a painting having one main focal point. The 'V' shape is fairly central, but the large dark patch in the right side of the background draws the eye over, only for it to be quickly pulled back into the detailed table intricacies located within the 'V'.

Looking at light and how it changes

Understanding the rules of tone, form, colour and space serves only a limited purpose unless it addresses real-life visual problems. When trying to create the illusion of reality, we must consider more fully the nature of light. It directly affects the tonality of a picture, how we render solid objects illuminated by it, the colours used to communicate its reflective qualities, and the sense of space the overall combination achieves. Light is as dazzling as it is elusive; it transforms and is transformed and follows a clear, daily cycle from dawn to dusk. The transitory nature of light has enticed and thrilled successive generations of painters as they have sought to capture its passing with the sweep of the brush.

Light greatly affects the surface and texture of the forms onto which it falls. In this ink sketch focusing on the stark winter tree, early morning light evenly illuminates all aspects of the composition. The reeds growing up around the base of the trunk are as brightly lit as the trunk itself: only where the roots submerge into the stream does the light not clarify the form.

The greatly reduced light falling on the scene at dusk creates the antithesis of the first sketch. The tree forms are silhouetted in the fading light against a bleached sky, although the bolder features, such as the texture of bark, can still be observed. This type of study reinforces the point that light really does profoundly alter the appearance of objects, thereby giving the artist licence to change the reality of the setting, or reshape its meaning within the context of a painted composition.

A longer, more thoughtful pencil drawing was completed of this isolated spot near the bend of a winding river. The lightness of touch and even grey tones indicate the calm, spring setting. By making this preparatory study, I was able to edit out unwanted detail and familiarize myself with the light of the day, before making the final acrylic and pencil sketch (right).

The final piece was built with pale washes of cobalt blue and cadmium yellow blended to form a medium green on the water's surface. Burnt umber was used to create the bare trees, and mixed into cobalt blue to create the masses of riverbank foliage. Pale flecks of cadmium orange in the foreground leaves helped to warm the foreground and create greater depth.

TIP

Cut a square or rectangular aperture in the centre of a plain sheet of paper, and lightly tape it to a window overlooking an interesting outside location. Simply observe and record the changing light and weather patterns at set intervals of the day as seen through your viewfinder.

With experience you will discover the colours that best suit different seasons and times of the day. A typical winter palette includes purple-greys, and permutations of raw and burnt umber, best laid in glazes to produce a dark, melting quality. This gestural study made on a cold winter's eve has the added contrast of warmth in a low, setting sun, just sinking below the riverbank. Here, the cadmium red and orange give the picture a glowing lift, and add fuller depth to the composition in the light-reflecting ripples on the river's surface.

Getting inspiration indoors

There is a potential subject for painting in virtually everything that passes before our eyes. Seeing the world afresh and creating a personal interpretation through brushmarks and colour is our task as artists. This can seem daunting at first, so start with familiar subjects from around your own home. The combination of different shapes, hues and patterns is endless, but so often either missed or taken for granted. As you begin to open drawers and cupboards, worlds within worlds appear. A lifetime's study could be found without ever having to place a foot outside.

Using windows

Windows are a natural 'viewfinder' and aid to composition that can integrate a number of key elements within a subject. They also provide a symbolic device in painting that many have used. Pierre Bonnard (1867–1947), a key member of a the 'Nabis', a post-Impressionist group, frequently painted vistas through the french doors of his sitting room, which overlooked a lush Mediterranean valley. This contrasted sharply with his sparse room, and suggested a simple, even austere life and a sense of isolation.

Still life

This traditional genre is a constant source of inspiration for artists who wish to develop their all-round painting skills. Form, colour, texture, expressing spatial relationships between objects, and placing elements to achieve balanced composition, are all topics encountered with still life. It is worth researching past masters to see how they responded to their subject matter. For the Dutch and Danish painters of the seventeenth century, realism was key, and perfect rendering of the hard, reflective surfaces of jugs in contrast with soft, velvety fruits and flowers became an obsessive artistic fashion.

A man sits at a table drinking coffee, but not at an ordinary café; this one is situated inside a large glasshouse containing sub-tropical plants. The juxtaposition of the figure and table, dwarfed by the immense, overhanging foliage, presents a very different way of painting interiors. This blurring of the division between the indoor and outdoor worlds adds considerable interest to an artistic subject.

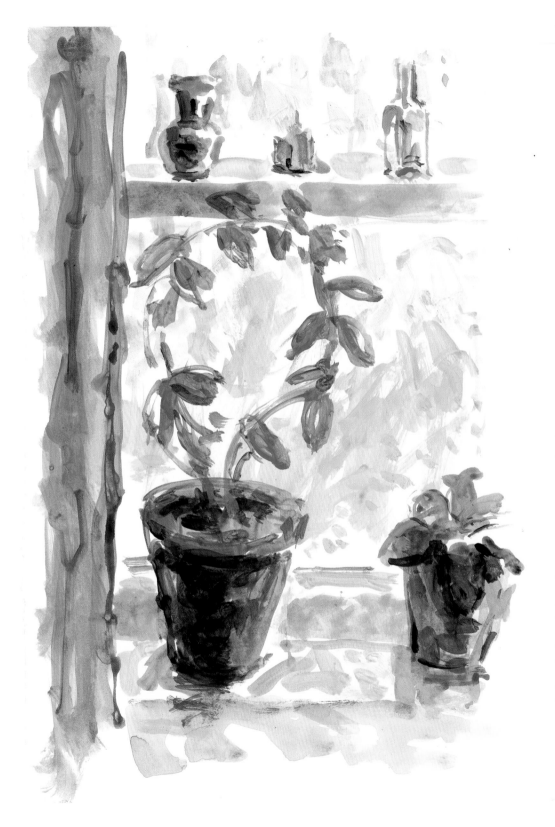

A brightly lit windowsill with jugs and potted plants was an ideal subject for a swift oil sketch. This type of subject is known as a 'found' still life, in which none of the elements is moved to create a formal composition. A soft-pencil drawing was made first (above). This helped to establish the tonal contrasts created by the light streaming through the window. The palette for the colour study (right) was kept to a handful of low-key hues – burnt sienna, yellow ochre, cobalt blue, and viridian. The brushstrokes were fast and spontaneous, with little overlap of colour, in order to keep the freshness and feeling for light. Areas of untouched paper reflect light, contributing to the airy feel of the sketch.

Getting inspiration outdoors

Having gained in confidence from working indoors, you can progress to the great outdoors. The history of both oil and acrylic painting provides plenty of suggestions, from seascapes to cityscapes, landscapes to moody weather studies, and paintings celebrating light and colour. You will need to venture out to meet your subject face-to-face and then, depending on the conditions, either complete the painting *al fresco*, or make a series of quick colour studies and notes to capture the energy and atmosphere of a scene.

Start at home

Begin in a familiar place such as your own back yard. Twisting tree branches, weathered wicker fences, a dilapidated shed brimming with garden tools, pots and ephemera – these all make excellent studies. Even the most mundane corner of a vegetable patch can be magical when low autumn sunlight throws its muted rays into the foliage. As you overcome the challenges here, you can start moving out in search of more difficult subjects.

Never stop looking and consider the potential artistic merit in all that you see. Let your visual inquisitiveness be aroused; be ready to be inspired. The extraordinary things of life are often hidden within the ordinary – try to rekindle your childhood curiosity that soaked up new experiences like a sponge. Travel as much as possible, and record the beauty of other cultures. By doing all this, you will never be without great subjects for painting.

This washing line in a back garden is proof that you don't have to travel miles to discover lively, usable subjects. The spontaneous acrylic sketch was vigorously executed with pure wet-in-wet pigments, using quick-fire jabs of the brush. This could be developed by creating a sequential journey around the garden, isolating various individual subjects for rapid, visual documentary.

Landscape

Hazy mountains stretching back into the clouds, winding rivers that meander through wooded valleys or dry scorched plains, all make inspiring topics for the landscape painter. Topography has been a subject for painters for millennia. There are infinite possibilities open to the artist when reinterpreting natural forms.

Seascape

This can also be a hugely varied subject, from lazy summer days on the beach to rugged coastline walks. The sea and its associated weather patterns can offer truly spectacular views, especially sunsets reflecting through breaking waves or an approaching storm. The architecture of the coast can also inspire – fishing boats, harbours and quays, jetties and piers, kiosks, arcades or genteel hotels and apartments.

Weather

William Turner (1775–1851), John Constable (1776–1837) and Caspar John Friedrich (1774–1840), all studied the effects of changing light, weather and seasons. Friedrich's paintings in particular express a spiritual link with nature seen through vast, empty swathes of sea, impenetrable mountain ranges, and eerily lit polar ice floes.

Follow their example by choosing a place and recording climatic changes through the day with quick acrylic sketches. For a greater challenge, set up a longer project over a number of days, and make a sequence of paintings from the same location, exploring and developing the techniques you have learned.

Town and cityscape

The hustle and bustle of daily life in the city is difficult to replicate in two dimensions. You will need to train your memory to see and remember movement as it passes you by. Keep your lines simple, direct and not overly fussy. Lay your colour in clear passages to capture the essence of the scene rather than details.

Markets are a great source for the urban painter. The stalls are a cornucopia of colour that assault the senses and fire the imagination, such as this sparkly display of Chinese herbs and spices lying in their trays.

Working on location

Both acrylic and oil are suitable for the outdoor artist, but have their pros and cons. Oil allows you the time to consider and correct, but is awkward if you do not have a protective holder for your wet canvas or panel. Acrylic is great for location sketching – but on a warm day, before you have had time to mould and shape your strokes, they are dry! Then there are other pitfalls of being outside: changing light, dust blowing into your paint, and fickle weather. However, it is very worthwhile; every painter should muster the courage to pack up a kit bag and head for the great outdoors.

Assemble a ready supply of prepared boards or canvases and keep them to a manageable size: up to 40 cm x 50 cm (16 in x 20 in). Store brushes correctly so that they do not stand on their heads. Secure them in a cardboard tube, or slotted into a specially made, pocketed canvas bag. Pads of disposable palettes made of greaseproof paper are available, or you may care to cover your own

wooden palette with cling film, which you simply roll up and dispose of at the end of the day.

Wherever you choose to set up, follow any public warnings and notification of private property. If in doubt, check, and if necessary seek permission before you start. Be courteous to those around you and never put yourself in a dangerous situation.

Footwear should be appropriate for the place you are visiting. If you are planning to walk out into the countryside, a sturdy pair of boots will suit most types of terrain, and keep your feet warm and dry.

TIP

Keep in the shade wherever possible. The sun's glare will make tonal approximations impossible, and over-exposure to the sun can cause heatstroke and sunburn. Protect skin with sunblock and cover up.

*A **pochade box*** *is very useful for painting outdoors in oils and acrylics. The base of the box holds paints and equipment, and there is a slide-out palette. The recessed lid can hold several small boards and also acts as an easel. When selecting your painting equipment, take only what you will actually use: a small selection of colours and brushes; palette and dipper; a small bottle of thinner and/or medium; a rag; a small sketchbook and pencil or charcoal.*

*A **good, lightweight waterproof rucksack*** *with small, separate compartments is ideal for carrying your equipment, as is a sketching stool with integral bag. But keep bags to a moderate size – you don't want to arrive on site exhausted and with an aching back.*

*Whether or not to use an **easel*** *is a matter of personal preference. While some artists are happy to rest their board on their lap, others wish to stand at their work as they do in the studio. A box easel folds out of a case (which also carries paints) and stands on sturdy, tripod legs. A folding sketching easel has three adjustable legs, but is less robust because it is very light, and this can be a problem in strong winds. However, on soft ground the legs can be stabilized by binding them to anchored tent pegs.*

Making pictures 93

Looking at the masters

While it is vital to know the basic principles and techniques of picture making, for true inspiration and guidance nothing can better a study of the great masters. Understanding the context in which their themes were developed, and their structural and compositional choices made, will help you to develop a style of your own.

It is best to visit galleries to experience the full effect of a work, but when this is not possible, buy books and postcards or borrow artist's monographs from libraries. The Internet is a great source of information on artists. Vary your selection of artists – the broader your influences, the more likely you are to produce work of interest using a greater range of materials and techniques.

I have selected four modern masters to discuss on these pages – others follow. My sketches are not replicas, merely my own interpretations worked in the manner of the greats, so the hallmarks of the artists may not be obvious. However, these loose copies have greatly benefited and enhanced my own handling of paint and directed my approach to creative picture-making.

After Derain

Developments in art can always be linked to earlier movements. Both Paul Klee (1879–1940) and Wassily Kandinsky (1866–1944) were very aware of the 'Fauves' (literally 'Wild Beasts') who pushed the accepted boundaries of painting at the turn of the twentieth century. Their unswerving use of bold colour and rhythm almost eclipsed subject matter. It could be argued that this was the first form of abstraction. One leading exponent, André Derain (1880–1954) reduced his view of boats to stabs and strokes of brilliant yellows, reds and blues; mere fragments of colour which kiss as they pass by on a large sea of raw white canvas.

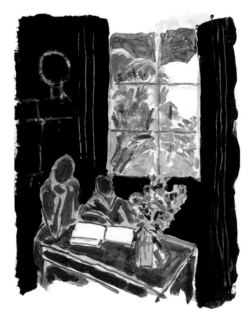

After Picasso

Pablo Picasso (1881–1973) had a long and prolific career that was a major influence on the development of twentieth-century art. This impression of his 'Head of a Sailor' indicates the direction he was taking; it is a typical forerunner to the contorted forms of the women in his 'Les Demoiselles D'Avignon'. His eclectic pathway into abstraction came out of a passion for ethnic art such as African carvings and masks, and many of his earlier portraits have the simple, strong lines of a carved mask. He cut and changed the appearance of his subjects with a use of paint that was nearer to drawing than the softer, more lyrical approach associated with painting at the time.

After Matisse

Henri Matisse (1869–1954) began his career copying the eighteenth-century masterpieces of fellow Frenchman Jean-Baptiste Chardin (1699–1779), and completed it helping to define twentieth-century painting. Like Picasso, Matisse reinvented his style a number of times during his long and varied career. 'The Silence Living In Houses' belongs to the last period of his painting, in which he applied broad, relaxed strokes of strongly contrasting colours to shape-orientated compositions. Matisse used the sgraffitto technique here, scratching into the surface of the canvas to denote background features. Light is evoked by contrasts of hue, rather than by imitating the actual colours perceived.

After Modigliani

Amedeo Modigliani (1884–1920) was heavily influenced by Cubism, Venetian Renaissance colour, and the elongated shapes of primitive African sculpture. 'Portrait Of A Girl (Victoria)', exploits simple shapes and earthy reds, browns and ochres to create a graceful figure, positioned in front of the strange, partially abstract door and its panelling. The combination of the rhythm of the figure set against formal passages of reduced colour presents a unique and telling portrait. He first tinted the canvas with pale yellow ochre, before building up layers of burnt umber and Indian red – the yellow ochre base left to depict the simple flatness of the face. Swift drybrushed strokes of burnt umber on the coat complete the image.

TIP

Allow painting past and present to influence your work. Curiosity about every subject and every method of painting will inspire you to interpret the world around you in all its depth and richness.

After Pissarro

The French Impressionist Camille Pissarro (1830–1903) sought to capture the fleeting effects of nature using the optical mixing of small dabs of complementary colours to achieve the sensation of daylight reflecting upon its subject. Peasants at their work were a typical theme for him, and in 'Woman In An Orchard' (1887) gentle dabs of pure colour appear translucent on the white, unpainted canvas, delivering the effect of ethereal sunlight upon the scene.

After Bonnard

Working from memory and sketches provides a good foundation for painting with an imaginative edge. Pierre Bonnard (1867–1947) worked in this way to provide a recollection rather than a record of his subjects and used strong, vibrant complementary colours to evoke the hot, shimmering sunshine of southern France. Bonnard had no rigid procedure for applying paint, and this gave his subjects an unpredictable and exciting edge. Unlike the Impressionists, he first scraped down layers of colour before adding fresh impasto marks, and in places he also used layers of glazes.

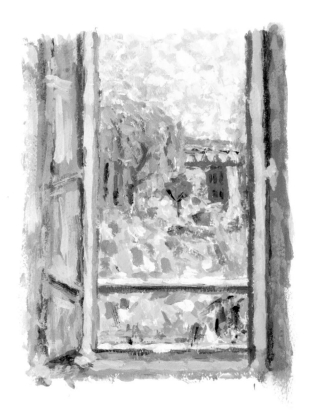

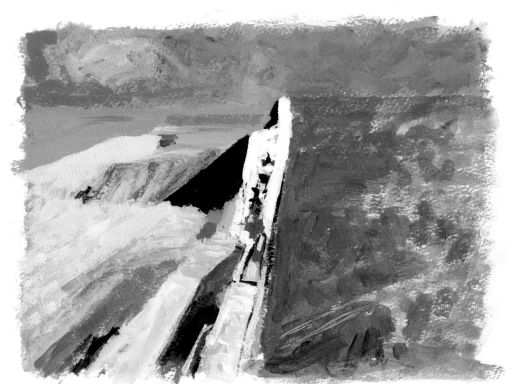

After Diebenkorn

Figurative elements in a land or seascape can sometimes appear as abstracts. The Californian painter Richard Diebenkorn (1922–94) demonstrated this with his great sensitivity to shape and colour and an innate understanding of pictorial harmony. His objects fall both in and out of focus, as they are simultaneously soft- and hard-edged. The passages of colour, laid as subtle nuances, gently overlap and envelop each other. Harmonious use of colour and the careful construction of these creamy passages of paint, create an emotional and eloquent sense of place.

After Rothko

This American artist's heavily laid, flat stains of colour covering a taut canvas describe shallow space, and a sombre mood. Mark Rothko (1903-70) characteristically built simple rectangles – usually asymmetrical – from successive washes of thin oil colour. Edges are blurred deliberately, wet-into-wet, and leave the canvas with a strange, glowing resonance. Where the saturated yellow band has been painted onto a paler washed stripe of red, the illusion of floating becomes stunningly potent. The subdued palette also heightens the experience, showing how powerful a limited use of colour can be.

The language of paint

Expressing ideas through paint can be considered as a type of language. Painting, like music, performance and creative writing is an alternative to the everyday language that is our most basic form of communication. Hard facts and information are best described in direct, simple phrases, but moods, feelings and sensory experiences such as texture and the play of light and shadow on surfaces require a more substantial exploration, and paint can offer this other language.

Paint strokes, daubs and marks can express surface appearance while at the same time delving into the imagination, recording the moment, or recounting the past. As you practise, your fluency should automatically begin to uncover a distinctive style of 'handwriting'. Nurture a working knowledge of other oil and acrylic painters: if a certain element of a painter's style appeals, it may become a strong influence on your own working methods. Imitation is an excellent way of learning how others have succeeded and can assist your development.

Acquiring a personal style is not something that occurs overnight – for some it can be the cause of considerable anguish – but be assured that with practice and thought you will achieve it.

TIP

Try to avoid becoming merely a style imitator by considering the intentions of your picture before you begin. Once you have decided what it is you wish to portray, think about the various pictorial elements– colour, tone, composition – as well as technique, and how they can be harnessed to express what you want to say. Style should always be secondary to content: what you say should be master of how you say it!

After Rembrandt

The Baroque master, Rembrandt van Rijn (1606–1669) evolved a revolutionary oil-painting technique. His breadth of paint handling and richness of colour are dazzling, combining thin glazes and heavy impastos to suggest, rather than laboriously mimic, the forms he painted. Sometimes, whorls and ridges of paint stand proud of the surface, reflecting light and thus giving a strong impression of three-dimensional form. The 'suggestive' nature of his work meant that canvases appeared unfinished, and the use of a heavy brown ground as a base was very unconventional.

Rembrandt was a master of chiaroscuro, interweaving soft lights and shadowy darks with a suggestive and allusive touch, as in this study I made of his self-portrait of 1662. His pictures have deep and universal layers of meaning which still astound us today. His personal language is clearly defined, and the purely sensuous delight in the physicality of oil paint paved the way for successive generations.

Abstraction

Many practitioners of figurative art view abstraction with unease. However, everything we see contains abstract elements, especially when areas of a scene are isolated and enlarged on the painter's canvas. For many painters, abstraction is the final destination on a creative journey that began in traditional art. By trying out abstraction for yourself, you are far more likely to accept the work of those who have made the choice to follow this route.

Abstract painters tend to fall into two distinct groups. The first are expressive and emotive, hurling vigorous brushstrokes and sensational hues at the canvas. The second are more concerned with logical and geometrical construction, often applying an equally strong and regulated palette. In 'taking his line for a walk', Paul Klee was proficient in both, as was Wassily Kandinsky, and both artists brought strict discipline to their work by rigorously applying the structures of music to those of painting.

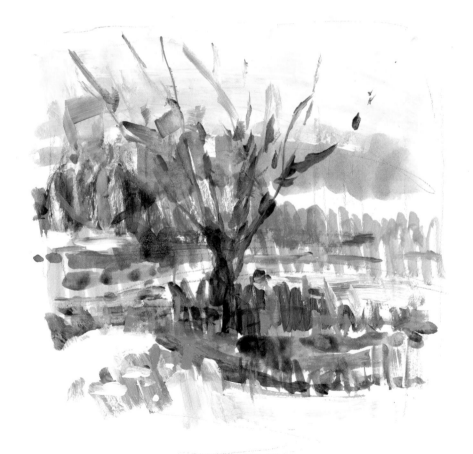

Rapid acrylic studies, made alla prima on a snowy winter day, provided the starting point for some abstract sketches. As I gazed around, I noticed the broken ice fragments beneath my feet – large sienna brown rushes encased in bluish-white slabs apparently floating on the marsh bed. The works that resulted were a purely sensory exploration of colour and texture, abstract, yet a remarkably accurate record of my experience.

EXERCISE

Cut out two L-shaped pieces of card and arrange them to form a square. Hold them together with paper clips. By altering the size of the aperture you can isolate small areas of a subject and discover new, abstract, compositional possibilities. The paintings on this page are examples of what this technique can yield.

Develop this technique by reducing the aperture of your viewfinder and laying it over a visually interesting part of an existing figurative painting. Identify the basic shapes and colours and create new abstract compositions with broad sweeps of acrylic. Develop the theme by changing the colours.

Rhythm

When music begins our feet start tapping, our bodies start to move following its rhythm and tempo, and before you know it, dancing is in full swing! It is not dissimilar with painting. Rhythm is created by a variety of brush strokes and colours following the movement or shape of certain objects in a composition, lending mood and expression to the picture. Patterns, shapes, lines and hues, often repeated, can set up an echo that appears in all parts of the composition. Structured in much the same way as beats in music, the nature of these elements, and the cadences they create, help to animate the picture.

A dynamic element

For some artists, rhythm is a crucial ingredient imparting vitality to their paintings. Even where colour is a strong element, rhythmic tensions add piquancy to a composition. Vincent van Gogh's (1853–1890) work perfectly illustrates this point. Having studied the great Dutch Baroque painter Peter Paul Rubens (1577–1640), van Gogh carefully considered the richness and saturation of paint applied to forms and their dynamic flow around the geometry of the canvas. Japanese prints were popular at the time and these influenced his ideas of precision and structure. Incorporating these qualities in his work allowed him the space to develop his own language.

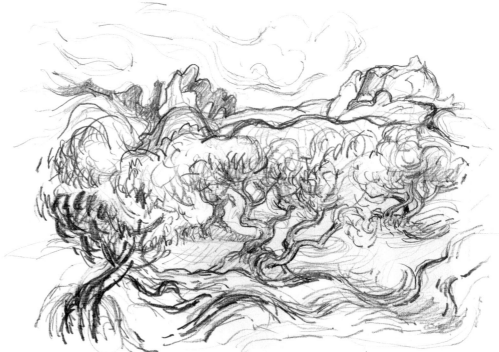

Catch the rhythm

With rhythm in mind, select your favourite masters, past or present, and break their work down into three stages, beginning with simple linear shapes and ending with an acrylic sketch. Identify the rhythms contributing to the success of the piece and try to emulate the master's strokes and consistency of paint.

To illustrate this exercise, I wanted to show the rhythmical aspect of van Gogh's work, so I broke down one of his compositions, 'Olive Trees in a Mountain Landscape' (1889), removing colour to

help focus on movement alone. The first, an ink drawing (far left), contains the key masses with directional strokes flowing around them to show the compositional balance and contrasts.

The second (left) is a more dense tonal drawing made with 2B and 6B pencils. Note how the key masses have now been shaded to describe the canopies of the olive trees. The shape of these is important to the overall rhythm of the picture – van Gogh has deliberately accentuated and stylized their gnarled and twisted forms so that

they echo the forms of the clouds scudding across the sky. The tree in the left foreground is also an important compositional element, as it bends into the picture and forces out towards the right, setting off a strong current of undulating marks. The background hills mirror these shapes and their movement.

The final sketch (below) repeats these elements using minimal colour, but even here, tone is not achieved by careful blending but through bold interwoven strokes, both short and long.

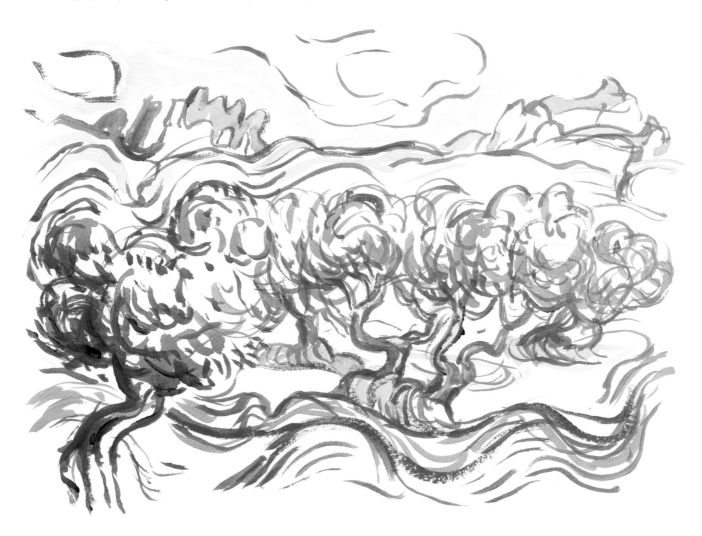

Masterclasses

Painting a townscape

French coast

Lagrasse, set in the heart of the wine-making region of the Aude, is a charming town. Its quiet atmosphere makes it the ideal location for sketching and relaxing. The intense colours experienced under the glare of the Mediterranean sun are reminiscent of the 'high-key' palette developed by the Fauve colourists, including Matisse and Derain, who lived and worked along the neighbouring French coast at the turn of the last century.

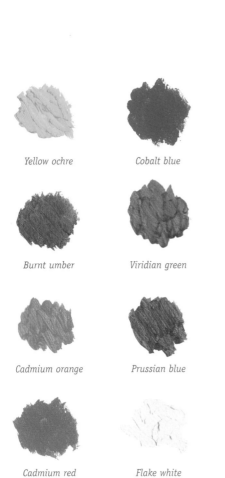

Yellow ochre

Cobalt blue

Burnt umber

Viridian green

Cadmium orange

Prussian blue

Cadmium red

Flake white

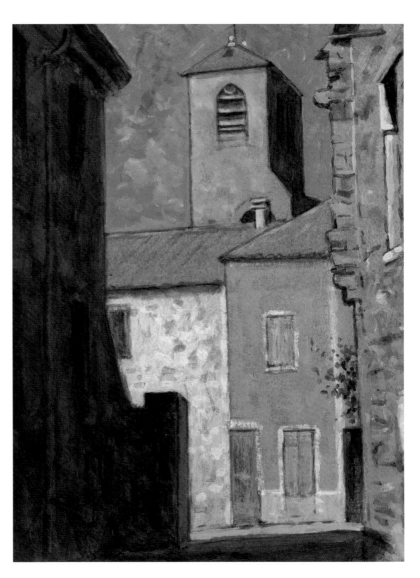

The architecture, local stone and ambient light all combine to express a strong sense of a place. Even the simplest town dwellings give clues about the lives of the inhabitants; though no figures are included in this picture, a human presence can be detected. Buildings are an excellent starting point when thinking about the elements you want to include in your painting. They readily define the edges and borders of a composition – their regular, interlocking shapes create a sense of scale and contrasting applications of tone and colour form the illusion of spatial depth.

Having wandered around the town, I finally chose this enclosed viewpoint for its simplicity, its vivid contrasts of deep shadow and glowing, sunlit colour, and the flat, pattern-like shapes they created. The light changed rapidly throughout the day, its quality affecting every reflective surface, and it was interesting to note how it intensified in saturation and warmth as the day progressed. The hardest task by far was taking a mental snapshot at the most impressive moment, committing the sensations to paper, and resisting the temptation to make more changes.

As the day progressed and gradually cooled, rich red turned to purple, yellow to gold and the painting was concluded under the lowering summer sun.

Techniques used

Dry brush (*page 39*)
Glazes (*page 40*)
Impasto (*page 42*)
Broken colour (*page 60*)

1 | *Initial tonal sketch*

To familiarize myself with the setting and work out the tonal accents of the composition, I made a fairly rapid drawing in my cartridge-paper sketchbook with a soft (6B) water-soluble pencil. Strong shapes were sketched in, and shadowy planes rapidly blended with a wetted no.6 round sable brush.

2 | *Line sketch for planning*

The simplification or 'editing' process is essential in all artforms. Resisting the temptation to include unnecessary detail is a difficult lesson to learn, but it makes the painting stage easier. Charcoal is best for preparatory drawings as unwanted marks can be dusted off with a dry rag. I kept this first line sketch as simple as possible using only defined, geometrical shapes, but paid particular attention to the angles of roofs and walls, which were vital in establishing correct perspective.

3 | Embellishments and adjustments

It can be helpful to lightly hatch the main areas of
shadow as a precursor to washing in the acrylic tones.
Although these extra marks serve only a temporary
purpose, they are a useful part of the initial planning
of the composition and help to clarify the depths of
hue that will need to be applied in acrylic glazes.
Note how the strong 'frame' of the foreground
building contains the background buildings and
leads the eye right into the centre of the picture.

4 | Underpainting and drawing out

Having got a 'feel' for the place, it was time to transfer the information from the sketches to a ready-
made illustration board. I chose one with a 'Not' (cold-pressed) surface as this has a medium texture and
carries fluid washes with ease. The application of drier strokes onto this surface displays a rougher, more
textured surface. Having mixed quantities of burnt umber and cadmium red with water, I applied a thin
wash ground over the entire board with a no. 10 hoghair filbert brush. The broad, controlled strokes were
executed in horizontal bands from side to side and top to bottom. The washes did not lay perfectly flat
but this did not matter as the reason for the underpainting was to create the warmth of the setting.
When dry, the scene was drawn out with light, sharp charcoal lines.

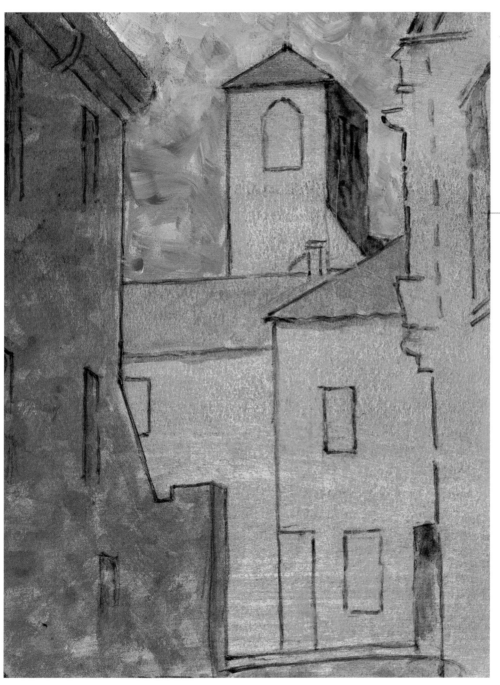

5 | **Laying in colour**

I built up a loose web of colour by employing both
thin and heavier washes of diluted acrylic, which
were dashed on with a fairly large, flat hoghair brush.
For the darker edge of the foreground building I used
a rich, warm mix of burnt umber and cadmium red
which I allowed to break unevenly across the surface.
When other colours are added, lower layers show
through and create a sensation of light. The sky was
painted with drier, impasto dabs, intermingling cobalt
blue with hints of Prussian blue. The roofs were
blocked in with a cadmium red and orange blend.

Finishing touches

To darken the shadowed areas, a further layer of cobalt
blue and cadmium red was brushed onto the foreground
and the road. The next stage was the addition of final
details with a combination of no. 2 and no. 4 hoghair
flat brushes. A smidgen of viridian mixed into cobalt
blue was perfect for the shutters and door, and simple
details of stonework and frames were drawn with a dry
brush and Prussian blue or white. Extra glazes of burnt
umber and yellow ochre were brushed over the tower and
walls for extra depth and realism of finish, and further
adjustments were made to the brightest wall so that it
would fully contrast against the walls on either side.

Landscape 1

Olive trees

Complex scenes can be difficult to paint, so bear in mind that the simplest subject can be very effective when rendered with good technique and use of colour. There is a subject in everything; sometimes an interestingly shaped object, such as a piece of machinery or the contorted trunk of a tree, can become a remarkable painting.

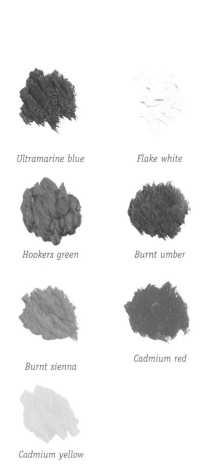

Ultramarine blue

Flake white

Hookers green

Burnt umber

Burnt sienna

Cadmium red

Cadmium yellow

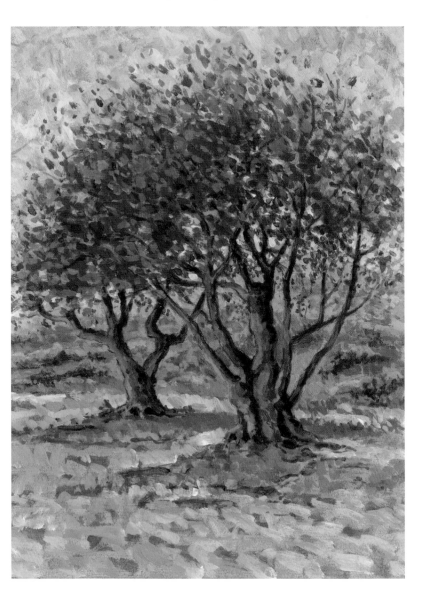

The heat of the day and the intense summer light suggested a study in the style of the Fauvists, who created works of stunning vibrancy by setting pure colours in conflict upon the canvas. At its height the sun was dazzling, and only the shade beneath the gently twisting boughs could provide any relief for the eyes. The optical stimulation of the light reflecting upon the baked earth, and the lush, spreading foliage, provided the contrasts for my interpretation of a sweltering summer day.

Initial pencil sketch | 1

Having decided what I wanted to achieve with the painting, I focused on the two olive trees in the grove, which were to provide the main theme. Their position relative to one another was perfect for a close-up study using a portrait format: with the larger of the two trees fanning itself out over the smaller one, a sense of spatial depth was created. This 2B pencil sketch contained all the tonal information necessary for the subsequent painting.

Even when you are painting a bright, colourful subject, try to restrict your palette to no more than eight colours throughout the whole composition. Of these eight, it is best if only four are used predominantly. The fewer the colours, the more harmonious and unified your pictures will be. Practically speaking, there is less cleaning and tidying up to do afterwards, too!

2 | Tonal sketch

This simplification of the first sketch into short, rhythmic flecks was necessary as a precursor to the main painting and the choice of techniques used. Even in a dry, monochrome medium, the direction of strokes and their minimal application to the surfaces receiving light, created a strong sense of brightness.

Charcoal outline | 3

Further reduction of marks came next by plotting the composition onto primed canvas with a soft charcoal pencil. A light, accurate outline of the trees was centred within the painting area, so that the canopies of the trees spread out from edge to edge.

4 | Underpainting

Cadmium red and burnt sienna oil paints were blended together on the palette and then thinned to create a dilute stain across the whole surface. The streakiness of this underpainting caused a rippling, light pattern over the surface, which would be allowed to show through the colours at later stages.

Base colours | 5

Although a strong, red sky did not actually exist, I deliberately painted the white and ultramarine blue onto this vibrant base to set up a complementary reaction. Heavier strokes of the cadmium red and burnt sienna mix were applied to form the solidity of the trunk and branches. Using drybrush technique, I marked in the distant slopes beyond the olive grove with gestural sweeps of a no. 6 round brush dipped into hookers green, with added cadmium yellow to lighten.

6 | Layering

This kind of painting requires a certain amount of thinking ahead: I left plenty of passages of red showing through the blue sky, particularly in the area marked out for the foliage, because this was going to represent the lightest tones. I also added darker tones at this stage, dabbing them into the underside of the leafy mass using a medium-sized hoghair filbert and burnt umber. The background was intensified with blue added to the green to darken shadow areas and create further undulations in the landscape beyond. To draw the eye back to the trees and add sparkle to the scene, small rocks were introduced in the foreground with quick, wet-in-wet strokes of creamy yellow.

Techniques used:

Underpainting (*page 46*)
Broken colour (*page 60*)
Blending (*page 54*)
Opaque brushstrokes (*page 42*)
Impasto (*page 42*)
Pointillism (*page 39*)
Wet-in-wet (*page 54*)

Finishing touches | 7

*Final tightening of the composition was made in the
studio, after the piece had had some time to dry, and
I was able to return with fresh eyes and make any
necessary amendments. I felt that the shrub-like density
of the olive trees' foliage was missing and filled both in
with very small, flicked strokes to emulate the slender
leaf shape of the species. As well as using French
ultramarine, hookers green and burnt umber I added
tiny marks of violet in the deepest shadow areas of the
foliage and branches. Remember to leave red showing
through the foliage, or you will deaden the required
effect! I added more brushstrokes in the foreground to
suggest the parched, stony earth. Strong bands of
creamy yellow were dropped in behind the trees to
enhance the contrast and add a greater sense of depth.*

Changing light

Window reflections

A window's reflective surface is the ideal place to explore the hues and tones peculiar to night scenes seen under artificial light. The edges of your canvas already mark out the window's rectangular frame, so there is no need to use any other method of viewing or cropping. The overlap of reflections from within the room colliding with those outdoors results in a coruscating display of colourful marks.

Seeing reflective surfaces under changing light is one thing, trying to paint them is quite another! When you pass a window in daylight your view of the reflection changes according to the amount of light hitting the window. At night the light comes from both directions; interior lights and streetlights mean the light reflection is often equally strong from both within and without. Added complications occur where objects closer to the window reflect with greater intensity, sometimes matching the tonal value of a close external object such as a tree, and a room full of shiny objects such as glass-covered pictures on walls or mirrors, bounce light in all directions. This masterclass is about being able to extract the important elements from inside and out, compose them in an exciting way on the page and express the illusion of reflected light successfully with the correct colours, tones and marks.

Prussian blue *Cobalt blue* *Titanium white* *Yellow ochre* *Hookers green*

Alizarin crimson *Burnt umber* *Cadmium red* *Cadmium yellow*

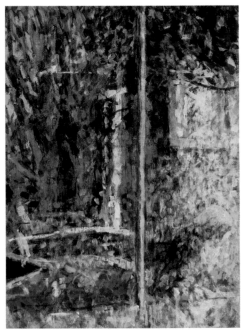

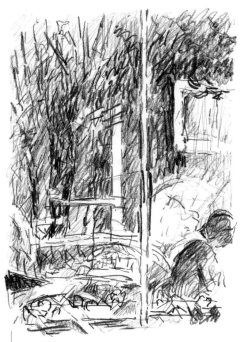

1 Initial pencil sketch

This vigorous study was drawn using a very soft, 6B pencil, noting the position of garden trees and fence posts. A quick sketch like this is an excellent way to familiarize yourself with a complex subject and to work out any compositional problems. I deliberately set the vertical window bar off-centre to create an intriguing compositional imbalance.

Charcoal tonal sketch 2

Charcoal is a good medium to convey very dark and medium tones, so having established basic positioning of the elements in the picture, a further working drawing was made with a soft, charcoal pencil. This sketch was more refined, but without losing the feeling of life delivered in the first sketch. Light was at its brightest on the right hand side, and shone in towards the woman sewing, dissolving her features into partial silhouette.

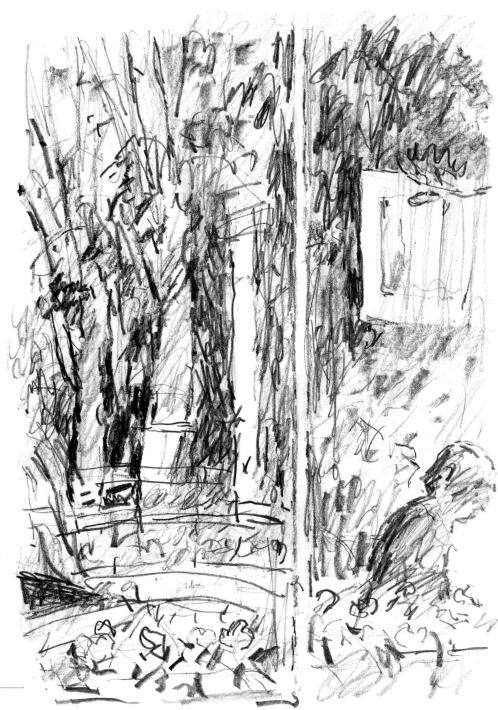

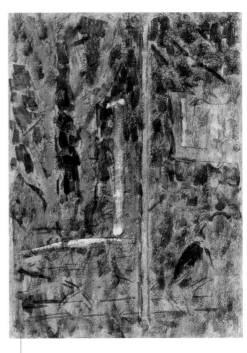

3 | *Basic outline on canvas*

An A3 canvas panel was coated with a couple of layers of primer, using a stiff-bristle decorating brush, to create a grainy texture. The bare minimum of lines was drawn on this in HB pencil (charcoal would have worked equally well) to enable accurate placement of the first paint strokes.

4 | *Scumbled underpainting*

With a large (no. 14) hoghair flat brush, I scumbled a mixture of cadmium red and burnt umber over the whole surface of the support to remove the stark whiteness and produce a low, warm glow, suggestive of evening interiors under artificial light. At this stage of the process, spatial depth became a priority. By establishing the darkest tonal areas with a mixture of Prussian blue and violet, the image started to come to life. Other tones were created around lighter objects such as the picture on the wall, using dry, broken brushwork. The linear pencil marks were also reinforced with a no. 4 hoghair round brush, and these floated on top of the new layers of mid-tone, carrying with them a significant tonal weighting.

5 | *Tonal glazes*

Glazes were added so that light was transmitted through the layers to give a bright lucidity. The trees in the garden were further enhanced with a darkening of the shapes in between and behind the branches, using strokes of hooker's green. Indications of edges of furniture catching the light were laid parallel to and directly over the trees with a creamy, impasto mix of cadmium yellow and white. The inside edge of the picture frame where glass reflected the angled light, was treated in the same way. Occasional smears of impasto alizarin crimson were introduced into the lower quarter of the picture, creating a contrast against the dark green, thereby establishing greater spatial depth through aerial perspective. A strong passage of tone mixed from violet and cobalt blue was added to the back of the seated figure.

TIP

When marking out your composition on the canvas or board, do not allow yourself to become obsessed with detail. It will emerge as part of the process as you work up the painting stages.

Final textural layering | **6**

In the final stage, a glittering transformation took place. The scumbled red underpainting, now the thinnest, lightest area, contrasted vibrantly with the denser strokes of violet, Prussian blue and hookers green. Further detail was added to the tree foliage, impressionistically dabbed on using a no. 4 hoghair filbert. The sensation of sparkling light around and above the figure was resolved with a build-up of translucent veils of cadmium yellow and white. Floating on top of the stronger, broken hues of Prussian blue and violet, these wafts of gauzy colour succeeded in producing the illusion of reflective light. On the main window pane, dragging marks of violet and white or cobalt blue and white over the very darkest areas – thereby forcing the greatest colour contrasts – produced further incandescence.

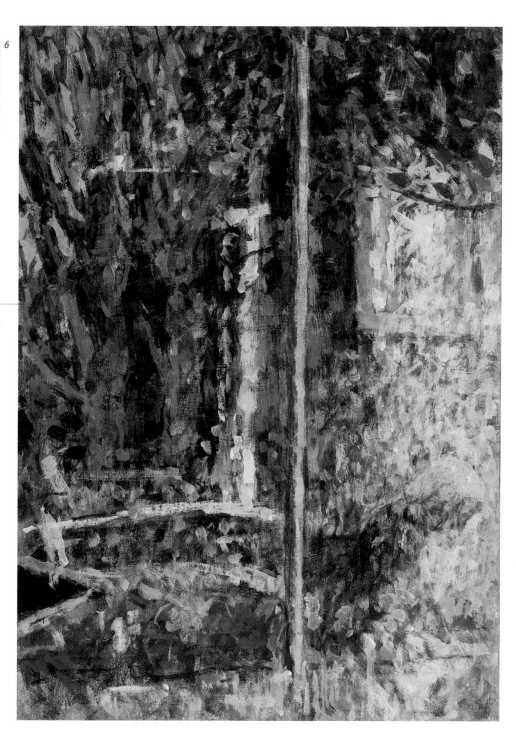

Techniques used

Underpainting (*page 46*)
Scumbling (*page 39*)
Dry brush (*page 39*)
Washes (*page 40*)
Glazing (*page 40*)
Broken colour (*page 60*)
Opaque (*page 42*)
Impasto (*page 40*)

Landscape 2

Greek coastal scene

Use your oil paints to record the changing nature of a landscape. Try to choose a spot where there is a wide range of topographical interest. Set up your easel as far away as possible from the bustle of traffic and other sounds, so you can concentrate in relative peace and quiet. Painting outdoors in wide, open fields or even high in the hills can be a very evocative experience. The sensations of light and colour can radically change from one day to the next, and just knowing that no two days are the same makes it very worthwhile.

Cobalt blue

Cerulean blue

Burnt umber

Alizarin crimson

Cadmium yellow

Cadmium red

Cadmium orange

Titanium white

Yellow ochre

Hookers green

A sketching trip to Greece revealed a land of marked contrasts: trees laden with ripening olives and pockets of arable farmland set against rocky hillsides and dusty tracks. The lush green pushing out of the barren, sun-scorched land was superb material for an oil painting depicting a wide vista and variable light. Two diverse land formations were broken by a gently lapping sea, which hugged bays and flowed around a natural spit adopted as a harbour. The boats and small farm outbuildings added the human scale, while the deep shadows indicated time of day.

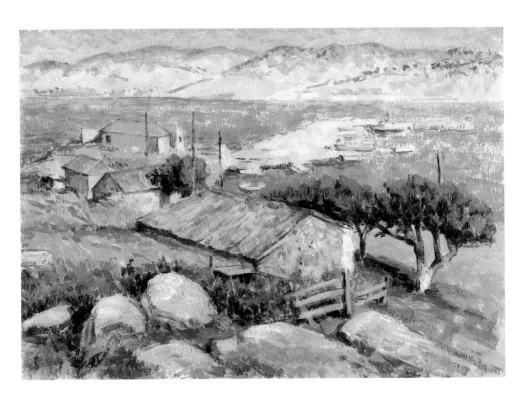

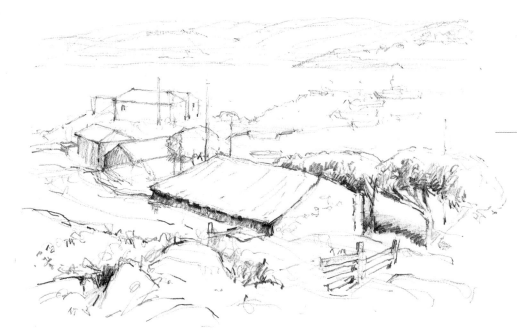

1 | Sketchbook study – pencil
A rendition of the surrounding scenery was made using a 2B pencil sensitively applied to cartridge paper. Sketching first is important because the unnecessary details can be edited out early on, allowing you to concentrate on those elements that are important to the final image.

Sketchbook study – pen and wash | 2
I was not convinced I had resolved all the visual challenges in the initial drawing; further observation of tonal ranges was needed in advance of the painting stages. A fineliner pen with sepia watercolour helped to establish darks, mid-tones and lights as well as detail and texture.

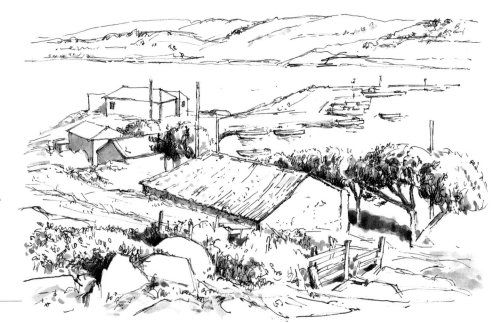

Colour, light and heat

The subtle colours of early morning or evening are far more interesting than the bleached-out noon-day light, and the long shadows add interest to the composition. To capture this complexity, the warmth of cadmium orange and red glazed over the vibrant washes of yellow ochre and sienna, were played against the cooler, pastel blues, pinks and greens with creamy yellows to give aerial perspective. This accounts for the successful illusion of depth in such a small painting.

TIP

Consider the picture as a whole and keep developing the background, middle distance and foreground at the same pace. This will assist your judgement of spatial depth.

Techniques used:

Priming (*page 26*)
Scumbling (*page 39*)
Washes (*page 40*)
Glazing (*page 40*)
Broken colour (*page 60*)
Opaque (whites) (*page 42*)

3 | *Initial outlines*

Using the sketches as an aid, the basic structures were outlined on a primed canvas board, first with a pencil, and then reinforced with a no. 3 round hoghair brush. The muted afternoon sunlight imbued the whole scene with an atmospheric stillness, the golden rays dictating the choice of medium: for its purity and translucence, it had to be oil.

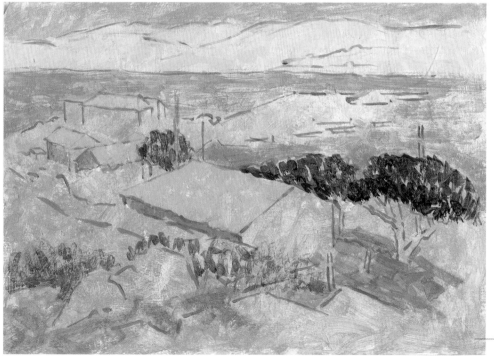

4 | *Broken colour and glazes*

To allow light to glow through sky and water, cerulean blue was dragged dryly across these areas using a no. 4 filbert. The rhythm with which the brush was pulled deliberately emulated the movement of the sea and sky. Establishing background against sky was important to create the correct feeling for space. The tiny hint of alizarin crimson was mixed into white and then warmed with an equally small quantity of yellow ochre. This was dotted thinly over the mountains and echoed in the roof shapes, thus providing a link into the middle of the picture. The use of broken colour not only allowed the yellow-ochre light through, but also added a rugged texture to mountains and tiles. Focus and foreground depth were the final considerations at this stage – impasto hookers green for the tree canopies, heavier glazes of yellow ochre with burnt umber to create shadowy recesses beneath the rocks in the foreground and the backs of the barns.

5 | Subtle colour additions

The brilliant light on the mountains and roofs was enhanced with a light tone of cadmium orange and white. Initial darkening of the twisting boughs beneath the foliage and the back of the buildings was achieved using violet and white. Dilute hookers green was scumbled into the pasture to bring it to prominence. The distant spit of land was brightened with a pinkish-white glaze to simulate sun-bleached sand.

6 | Detailed textural and tonal finishing

Care had to be taken not to overwork the details and lose their subtlety. A two-day break allowed the panel to dry. Detailing is not outlining, it is the addition of dabs of paint with correct colour and tonal value to create the illusion of form and space. With this in mind, I moved around the scene flicking in the odd dash and fleck to draw areas into prominence. For example, the addition of windows on the farthest building was all that was necessary to complete the description. Shadows were further deepened with violet straight from the tube.

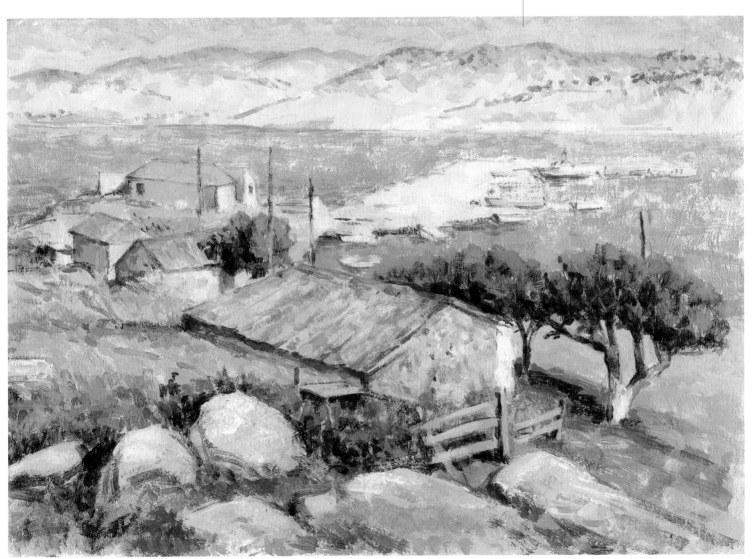

Portrait

Study of Walter

No subject is as complex or as challenging as the human form, and portraits have the most intricate set of visual problems to be solved. Not only do you have to consider form and underlying bone structure, but also personality and unique physical characteristics to portray the essence of a person through their face. The buttery consistency of oil and acrylic paint allows you to 'sculpt' the forms of the head.

Mastering portraiture is a lifetime's study in itself. The ease with which 'snapper' Frans Hals (1581–1666) caught the essence of the sitter in an apparently effortless dash of spry gestures remains as remarkable today as it was in the seventeenth century. When you do feel that you are capturing a likeness, it is very fulfiling. The well-painted portrait, like a good photograph, becomes curiously accessible to a much wider audience than was first intended, as it seems to provoke feelings of great empathy towards the sitter. How we see ourselves and others, and how others see us, can be very different: there is often public controversy at the unveiling of a new portrait of a well-known figure. Beauty is certainly in the eye of the beholder, and is a quality not only found in the young, unblemished skin of a child, but also the deeply etched furrows and wrinkles of the old. Both require sensitive handling and subtle application of paint.

Prussian blue

Yellow ochre

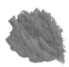

Burnt sienna

Cadmium yellow

Flake white

Burnt umber

Cadmium red

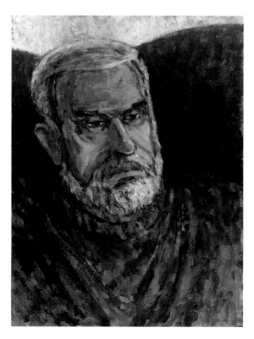

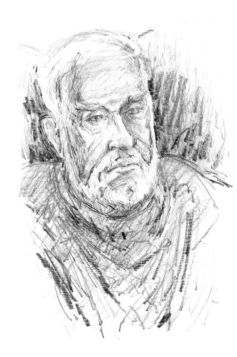

Understanding the model

Familiarize yourself with your model – it is probably best to select someone that you know reasonably well. Observe their mannerisms, habits, deportment, as well as essentials such as head shape from all sides and facial features such as nose shape, jaw line, brow, and hairline. Draw them in a range of wet and dry media. I chose to have a number of quick sittings and made rapid 15- to 20-minute sketches using fountain-pen ink and fineliner, soft charcoal pencil, and a range of B pencils. I moved around the sitter so that I would get an all-over impression of the three-dimensional quality of the head. You may consider photographs to supplement your drawn studies. This will provide useful reference when you come to trace your composition onto your support.

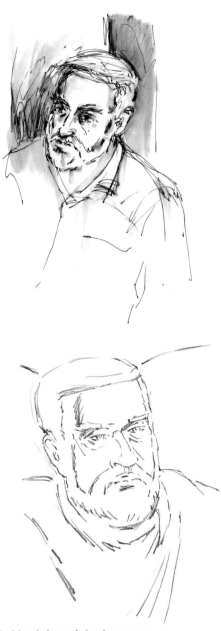

1

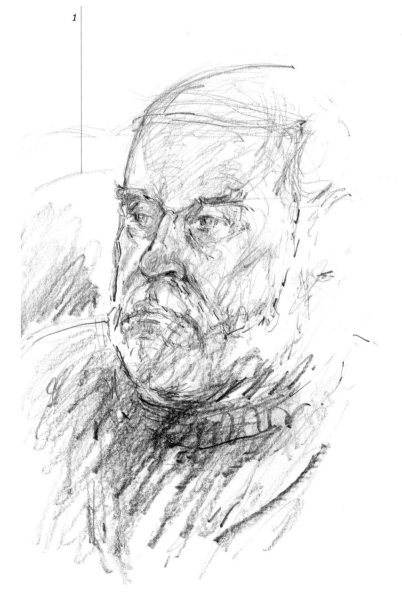

2 *Positional charcoal sketch on canvas*
I positioned the basic shapes of the eyes, nose, mouth, brow-line, chin and jaw on a primed A3 canvas panel with a sharpened charcoal pencil. It is critical that you draw the features as accurately as you can in order to capture a good likeness.

3 | *Underpainting*

A ground of burnt sienna mixed with burnt umber removes the stark flatness of the panel's surface, giving a warm base on which to build flesh tones. Resist using the pigment named flesh tint; it tends to make the flesh look flat and artificial. I danced a no. 10 flat hoghair brush over the surface, creating lively movements that formed the first of several vibrant layers. From the outset establish the sculptural form of the face with thinned burnt umber, darkening the tone in the shadows and recesses.

4 | *Glazes*

The form was made more solid with refined glazes of cadmium red mixed with a little yellow ochre, lightened with flake white. The first highlights were placed where the light caught the prominent features of the face. Burnt umber strokes dabbed behind and around the head helped to visually push the head forward, reinforcing the three-dimensional illusion. Glazes of Prussian blue were added with a no. 8 filbert, following the direction of the sweater's folds.

5 | *Building up the forms*

The same process was repeated again so that the sitter's head and shoulders became more solid, but without losing the translucent, painterly quality. The line of the sofa was defined with light touches of a no. 6 filbert and a blend of yellow and white. The modelling was increased, particularly down the left-hand side of the face, around the beard, and under the chin where light is not reflected. Older skin can have pigmented blemishes beneath its surface, providing the opportunity to play with textures without compromising realism. A milky white acrylic wash indicated the patterned weave of the sweater.

TIP

As you sketch the portrait head, carefully consider the placement of the individual parts of the face and 'feel' them around your own skull in order to gain a better understanding. Remember, they are never in isolation but always part of the collective whole. Run your fingertips across your temples, down over the prominence of the cheekbones, and into the hollows of the eye sockets. Visualize the different shapes as you go and relate them in your mind to their position on a drawn head. Note the changes of texture, between the tougher skin of the neck and chin and the soft, spongy lips. Evaluate the differences between the hard bone and softer cartilage that make up the nose.

Techniques used

Underpainting (*page 46*)
Glazing (*page 40*)
Broken colour (*page 60*)
Blending (*page 54*)
Opaque brushstrokes (*page 42*)

Highlighting detail | 6

I now attended to the upper part of the canvas with more light added behind the head in cadmium yellow, contrasting with the heavier daubs of burnt umber on the sofa. The skull's natural recesses were strengthened with burnt umber, cadmium red and Prussian blue, worked as before in short, broken strokes. I stood back to make a final assessment. The processes were repeated for more refinement using a no. 2 round brush to feather in the details with opaque colour. Where the broken strokes were too coarse, they were blended with a fan blender and flat no. 4 bristle brush.

Finishing touches

The defined shapes of eyelids, lashes, nostrils, gently moulded lips, flecks of beard hair and strands of hair running over the top of the head, made a major difference to the final image. The consistency of pale blue running through skin, sweater and facial hair was extended into the background colour, tying everything together and enhancing the rhythmic shape of the sofa back. Giving detail to the eyes is also essential. The expression and direction of the sitter's gaze can be key to the whole interpretation and sentiment of the piece.

Still life

Bottles and pears

Colour and composition are important to painting and should be practised regularly. Still life is also the most accessible way to practise techniques. The various colours and shapes found in an arrangement of fruit, flowers, cloths, pots and jugs will supply ample food for thought when it comes to planning which brushes and paints to use.

The still life used to serve a secondary purpose as part of the setting in a larger painting. A posed figure would sit or stand at a table next to a bottle of wine and perhaps a partly sliced loaf of bread. Many sixteenth- and seventeenth-century Dutch painters spent painstaking hours defining such scenes with the most extraordinary realism. The most complex fall of light upon a pitcher, or the veiled ripples in a silk tablecloth were so perfectly rendered that even now it seems you can reach into the canvas and touch the scene.

Today there are no rules for producing a still life, but there are choices to be made. Firstly, choose familiar yet interesting objects that you can arrange and leave undisturbed at a light source – a window or directed lamp. Decide what sort of theme you want to follow. Perhaps you are attracted to contrasts of texture or maybe pattern, rhythm and colour will shape the direction of the composition. Whatever your choice, keep it simple with a few differing shapes that will create impact with a balance of contrasting tones and colours.

Prussian blue

Flake white

Alizarin crimson

Cadmium yellow

Burnt umber

Yellow ochre

Cadmium red

Black

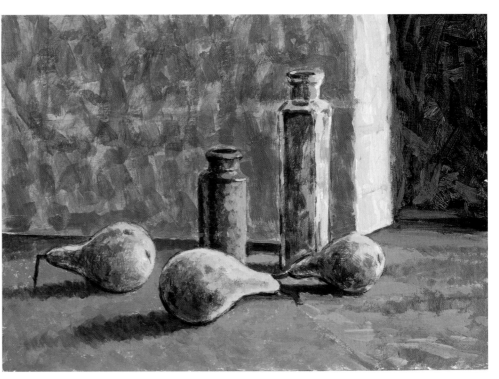

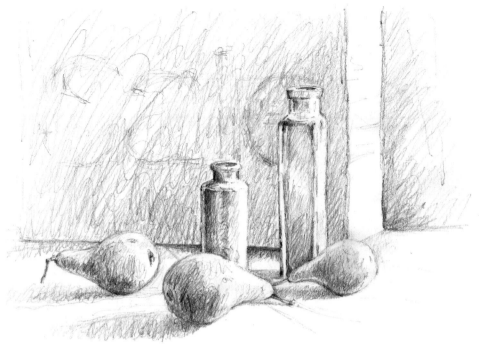

1 | Exploring form

I set up two tall vessels, one earthenware the other terracotta, against the prone forms of ripening pears on a shelf in front of a stiff, paper carrier bag. This provided an interesting background with light hitting surfaces at a number of levels. The surrounding surfaces were decorated in flat, brilliant colours, and daylight from the large window lit up these dazzling hues. I always spend time considering my approach, and usually make a number of pencil sketches before starting to paint. I began by exploring the forms using a gentle hatching and shading with HB and 2B pencils.

TIP

I created this acrylic study at a moderate pace. If you want to prolong the drying time of the paint so that the work is not rushed, add a retarding medium (see page 23).

2 | Tonal sketch

It is important to understand the effect the light source has on objects – the way it falls on their surfaces affects how we perceive their form. For a fuller range of tones, I chose the soft, smudgy marks of a charcoal pencil, and made a further study when the morning light was at its brightest. To achieve the fullest description of form, it was necessary to leave bare white paper showing through, and contrast this with the black charcoal.

3 | Positional charcoal sketch

The last preliminary sketch, also drawn in charcoal, was a simple one to allow me to evaluate the composition. Note how the bag comfortably covers three quarters of the background before its narrow edge dissects the space. The tallest vessel echoes the vertical emphasis created by the bag, and the bulbous fruits counterbalance horizontally and with strong symmetry.

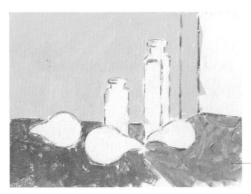

4 | Initial block-in

Confident that the basic tonal and compositional problems were solved, I primed an A4 panel with a couple of coats of white gesso and lightly drew in the basic elements using a no. 6 round bristle brush and dryish, burnt umber paint. When this had dried, I broadly underpainted the main areas with thinned washes of cadmium yellow (the bag), and alizarin crimson and cadmium red (the shelf).

Establishing form | 5

Coloured glazes were added with a selection of hoghair filberts, all the time refining the shape and surface texture of the objects. The thin paint picked up the grain of the gesso priming, giving the image a discreet texture. To re-emphasize the shapes of the vessels I loosely outlined them with the tip of a brush. Shadows placed underneath the pears helped to reinforce their roundness.

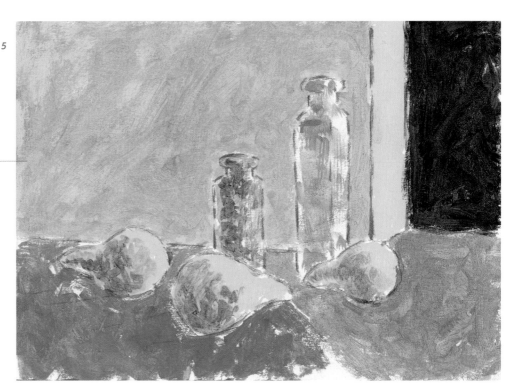

6 | Adding opaque touches

In the final stage of the painting, the glazes became more pronounced through the delivery of shorter, directed brush strokes. Small amounts of white were entered into the mix for opaque, white highlights. Burnt umber, mixed with cadmium red and a little white, produced an opaque creamy colour that gave the earthenware container its appearance of solidity.

TIP

It can be very tempting to smooth out broken colour. Try to resist this and have the confidence to know that your strokes are adding a unique paint quality to the study.

Underpainting (gesso) (*page 46*)
Scumbling (*page 39*)
Washes (*page 40*)
Glazing (*page 40*)
Broken colour (*page 60*)
Opaque (whites) (*page 42*)

7 | *Adding the final touches*

Further details and textures were built up with a no.
6 hoghair round. The picture was set aside to dry
and not looked at again for another day. Fresh eyes
are necessary to re-evaluate your work. Extra light
cutting in across the darkness of the adjoining
room was added to lift the mood of the picture.

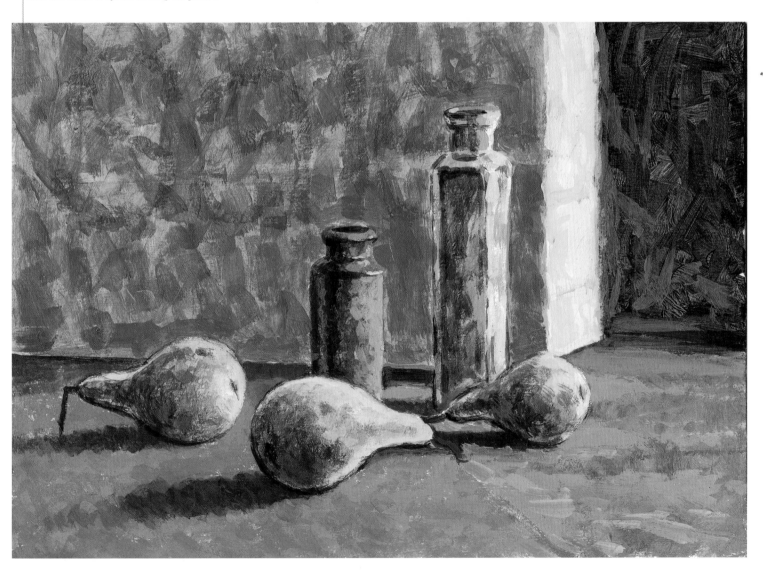

Series painting

By the sea

Sunshine, a gentle stroll along a sandy beach, ocean views and combing the shoreline for unusual flora and fauna – these are just some of the delights to be experienced on a summer break by the sea. Of course, winter can be equally inspiring for the artist – the different weather will suggest a quite distinct palette. There will be fewer people around – an angler or the occasional jogger replacing a seafront full of daytrippers. Here we try something different and document those observations in paint – a series of holiday 'snaps', if you like, recorded with pencils, pens and paint.

Spend some time exploring a beach or harbour; observe and record the shapes and colours of boats with their multicoloured sails; familiarize yourself with the movement and shapes of waves, foam, breakers and swells. Look at the light and colour, noting how they change the tone and definition of objects. Perhaps this could serve as a theme for the trip: a sketchbook record entered at consistent and specific times of the day. The changes are significant, and something we so often take for granted.

My intention in journeying around this resort was to record the content and character of the place and the individuals within it.

Sketchbook studies

This ongoing record supports the body of paintings you produce. It is a place to germinate ideas that may grow into full-colour works on canvas at a later date. Get into the habit of carrying a sketchbook with you at all times, recording as the moment dictates. If occurrences are fleeting; make shorthand notes; if you have the time to sit and watch the world go by, then a fuller tonal rendition is appropriate. Try to have clear in your mind the intentions of your drawing before you begin.

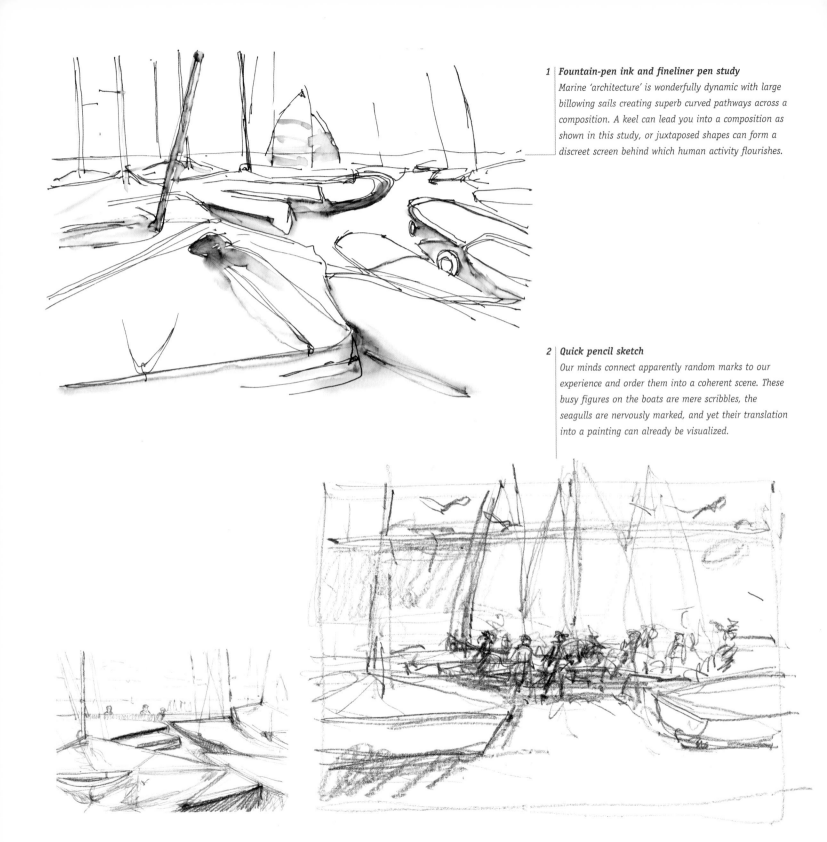

1 Fountain-pen ink and fineliner pen study
Marine 'architecture' is wonderfully dynamic with large billowing sails creating superb curved pathways across a composition. A keel can lead you into a composition as shown in this study, or juxtaposed shapes can form a discreet screen behind which human activity flourishes.

2 Quick pencil sketch
Our minds connect apparently random marks to our experience and order them into a coherent scene. These busy figures on the boats are mere scribbles, the seagulls are nervously marked, and yet their translation into a painting can already be visualized.

Techniques used:

Priming (*page 26*)
Underpainting (*page 46*)
Scumbling (*page 39*)
Broken colour (*page 60*)
Opaque (whites) (*page 42*)
Impasto (*page 40*)

3 | *Pen and ink sketch*

Shapes were recorded along with notes on colour to allow me to finish the study later. Note how the blues of the windsurfing boards 'ride' over the yellow ochre sand. The two colours react perfectly against each other, creating optical tension. This study has been made on a canvas panel with a burnt sienna ground, clearly seen through the rough, dry brushwork of both sailcloth and sky. The overall colour harmony of the blues is contrasted by the strong band of cadmium red dragged through the white sail of the boat positioned just off centre at the water's edge. This device is commonly used to draw attention to the main theme in a painting.

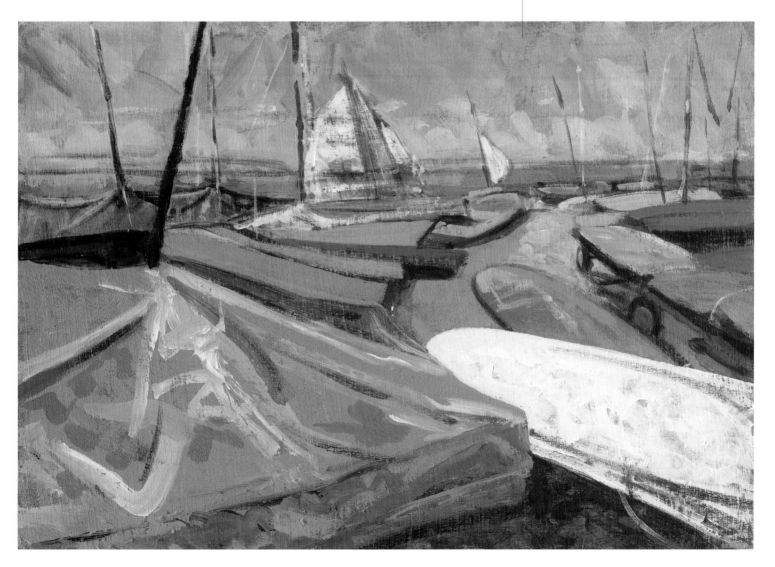

Compositional colouring | 4

On a warm, clear day and with plenty of time, why not record the broader scene? Here, the shoreline buildings and figures follow the prominent edge of the sea wall. The breakers punctuating the beach as they surge up from the sea give the composition a strongly constructed feel and set parameters within which to place the animated shapes of the figures. That the couple nearest us are crossing the line creates the illusion of further movement towards us as they have broken out of their designated area. The burnt sienna underpainting on the canvas shows through to create an energetic sky.

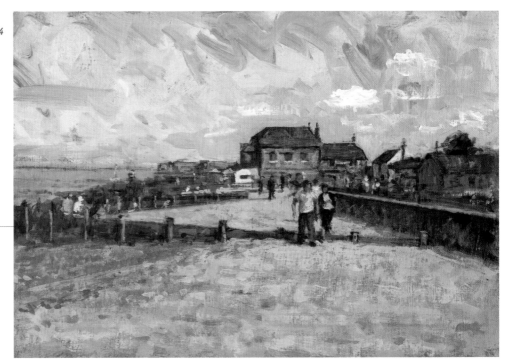

5 | Energetic study in situ

This sketch was painted during a knockabout game of beach football. As figures move, so they can be memorized in various states of animation, and a stroke laid down. A little understanding of anatomy is useful so that you can recreate the pose of the figures correctly. Dashing strokes add to the sense of move-ment – a good example of the fact that surprisingly little detail is necessary to define the narrative in the painting. An important rule when creating this type of paint sketch is not to overwork it. Keep it fresh and when you think that you are almost finished, stop, because you probably are.

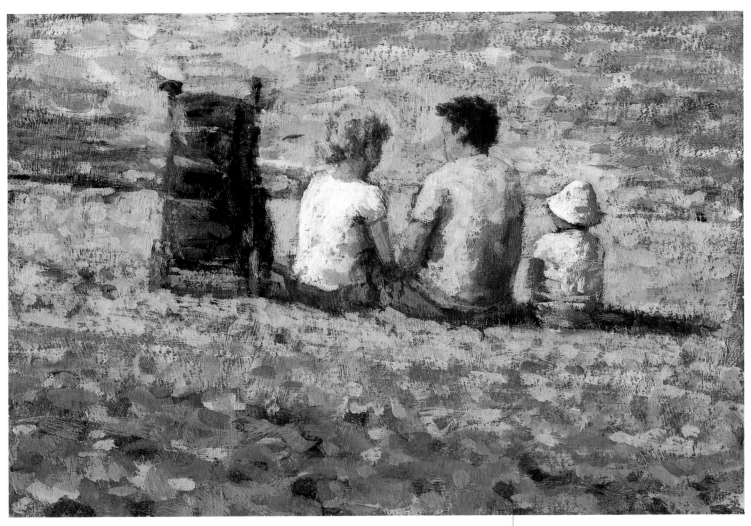

7 | *Detailed study*
*The soft brush and ink study of the family group
inspired this intimate study, which has as its main
focus the glittering light as it reflects upon the surfaces
of water and pebbly beach. Short dabs and flecks of
high-key colour intermingle with a low-key tertiary and
secondary palette. The sensation of light is created by
the optical contrasts of these opposing colours. It is
not always necessary to paint exactly what you see:
by understanding the theories of colour you can take
licence to make your point, for example the redness
of the sea. The use of thick white paint on the clothing
of the mother and child, is all that is necessary to
denote the strength of the strong afternoon light.*

6 | *Pencil, sepia ink and brush sketch*
*A family relaxing together at the water's edge are
here more gently replicated, with delicate drawing
and shading. Brushwork forces an economy of stroke
– fussy lines are just not available.*

Glossary

Absorbency
The extent to which a paper or canvas will soak up paint. This is controlled by a gelatinous substance known as size.

Acrylic gesso
A primer used for preparing supports for acrylic painting; differs from traditional 'gesso'.

Adjacent colours
Those colours closest to each other on the colour wheel.

Aerial perspective
Atmospheric conditions make distant objects appear lighter in tone and bluer. Aerial perspective in a painting is used to create the illusion of depth and distance by using paler, cooler colours in the background and warmer, brighter ones in the foreground.

Alla prima
Meaning literally 'at first', is painting completed in a single session, while colours are wet. Having no layers, it requires deft handling of the brush for a spontaneous finish.

Artists' quality paint
High quality paints with purest pigment content and strong colour.

Binder
The substance that holds pigment particles together to form paint. In acrylic the binder is a soluble polymer emulsion, whereas in oil paint it is linseed or vegetable oil. When the oil has dried by absorbing oxygen, the pigment is sealed onto the surface.

Blend
The soft, gradual transition from one tone or colour to another.

Blocking in
The application of broad areas of paint which form the base of a painting.

Bristle brushes
Tough, coarse-haired brushes, useful for laying larger areas of tone.

Broken colour
Colours placed next to one another to produce the optical effect of another colour – often applied unevenly intentionally to allow light to reflect through them. Can be created by scumbling or dry brush.

Chiaroscuro
A term describing strong tonal contrasts in oil painting; literally 'clear/obscure'.

Chroma
The saturation or intensity of a colour.

Chromatic
Belonging to a range of colours.

Cockling
The buckling of unstretched paper when it is wet.

Cold pressed (C.P.)
A technical term given to paper that has been manufactured through rollers at a cool temperature. Its surface is not as smooth as 'Hot Pressed', or as textured as 'Rough' paper. These papers are also known as 'Not' because they are 'not hot pressed'.

Complementary colours
Colours that sit opposite one another on the colour wheel and have maximum contrast. The complementary of a primary colour is made up of the other two primaries.

Composition
The arrangement of elements such as colour, light and shade, shapes, lines and rhythm in a picture.

Cool colour
Blue and green are generally described as cool. Distant colours tend to appear as cooler colours and appear to recede.

Darks
Areas of a painting usually depicting shadow.

Dilutent
Liquid used to thin acrylic or oil paints such as water or turpentine.

Dragged
Textured brushstrokes where the brush has been pulled across a support.

Dry brush
The technique of loading a dryish brush with pigment and dragging it across the surface grain of paper, giving a broken, feathery texture.

Earth colours
Colours made from naturally occurring clays, iron oxides, and other minerals. The ranges are ochres, siennas and umbers.

Emulsion
A term for liquid acrylic resin, suspended in water.

Easel
A stable frame to hold an artist's work in an upright or tilted position. Studio easels are heavy wooden constructions, sketching easels usually fold and are made of lightweight metals or wood.

Fat
Paint with high oil content.

Fat-over-lean
The painting of oil in layers, where each additional layer is progressively thicker in consistency. This ensures that each layer dries as a more flexible film than the one below, to prevent cracking.

Ferrule
The tapered, cylindrical metal collar that fits around a brush handle and holds the hairs in place.

Flat colour
Uniform tone and hue of a painted colour.

Focal point
The main area of visual interest in a picture.

Fugitive
Colours that are not light fast and will fade over time.

Gesso
A ground for oil painting made of rabbit-skin glue and plaster.

Glaze
Primarily an oil painting term, but occasionally used with acrylics to describe an overall wash in a single colour.

Grain
The texture of the surface of watercolour paper.

Ground
Any surface that has been primed or coated, to which paint is applied. A coloured ground is a diluted half tone that unifies the subsequent colours. It is also a translucent stain washed over white primer.

Half tones
Middle-range tones between highlights and darks.

Hatching
Shading drawn with a brush to create a tone.

High-key colour
Bright, saturated colour, usually painted on a white ground.

Highlight
The lightest tone in painting, either the unpainted whiteness of the paper or canvas, or white added to a colour to make the lightest tone.

Hot pressed (H.P.)
A very smooth paper made by being pressed through hot rollers.

Hue
Another name for a spectral colour such as red or blue.

Impasto
Thick application of paint, often straight from the tube.

Laying in
The first stage of painting onto the initial drawing, also called 'blocking in.'

Lean
Thinned paint with low oil content.

Lightfastness
The permanence of a colour when exposed to light.

Linseed oil
A quick-drying oil derived from the seeds of the flax plant, and used as an binder. The oil hardens when dried out.

Local colour
The intrinsic colour of an object unaffected by external conditions of light and atmosphere.

Low-key colour
The opposite of high-key colour, where hues are muted or unsaturated.

Mahl stick
A bamboo stick about 1.25 m (4 ft) long with a cloth ball end which rests against a wet canvas, which the artist uses to steady the brush.

Masking fluid
A solution of liquid latex used to mask out particular areas of a painting, which dries to form a rubber skin that can be rubbed away.

Masking out
The technique of using masking fluid or other material to protect areas of paper while adding paint.

Masking tape
A low-tack, paper tape used for masking or to temporarily affix a sheet of a paper to a drawing board. It peels off with out damaging the surface of the paper.

Medium
Describes the material used in a painting; the material used to keep pigment together; or any other material added to oil or acrylic to change the way it behaves.

Monochrome/monochromatic
A painting or drawing made in tones of a single colour.

Negative space
The spaces between objects in a composition.

Neutral colour
The dulling or neutralising effect of mixing two complimentary colours. If mixing is continued grey is the result.

Not paper
Cold-pressed paper with a fine or semi-fine grain surface. Literally paper that is 'Not hot pressed'.

Opaque
Non-transparent painting medium that light cannot reflect or pass through.

Optical mixing
The illusion of creating a new colour by placing two colours beside each other, rather than mixing them in a palette. Most effective when the colours are viewed from a distance and appear to the eye as a single colour. (See Broken colour)

Overlaying washes
The technique of painting one wash on top of another to gradually build up depths of tone or colour.

Palette

A flat tray for mixing colours, normally made of wood or plastic, often with a thumbhole to steady it on the hand. Plastic palettes are available with multiple wells incorporated in the tray for mixing a number of colours simultaneously. An 'artist's palette' also refers to a personal choice of colours.

Permanent colours

Pigments that are lightfast and do not fade.

Perspective

Representing a three-dimensional object on a two-dimensional surface requires the use of perspective, because objects appear smaller as they get further away. This is achieved by drawing lines to converge at a horizon line or vanishing point, which is the artists eye level (or the position the artist assumes this to be). Lines above the artist go down to the vanishing point, and those below the artist go up to the vanishing point.

Phthalo (cyanine)

Modern, copper-based organic pigment of transparent blue or green with excellent lightfastness.

Pigment

Coloured particles, usually finely ground to a powder, which form the basic component of all types of paint and drawing materials.

Plein air

Painting in the open air.

Primary colours

The three colours, red, yellow and blue, which cannot be made by mixing other colours. In various combinations they form the basis of all other colours.

Priming

A base coat applied to a support prior to painting to seal the surface to prevent too much absorbency.

Receding colour

Colours, such as pale blue, which appear to the viewer to recede, thus creating the illusion of distance in a painting.

Resist

The process of preventing contact between water-based paint and paper or canvas using an oily or waxy film as a mask. Materials such as candle, wax crayon and oil pastel adhere to the paper surface and repel or 'resist' water. Unwaxed areas receive the paint resulting in interesting broken colour effects.

Retarder

Medium added to acrylic to slow down the drying process. Can alter colour.

Rough

Papers with a highly textured surface, often hand made.

Sable

Tail hairs of the mink, used to make soft, fine brushes suitable for detail work.

Saturation

Denotes a colour's intensity: saturated colours are vivid and strong, unsaturated colours are pale and dull.

Scratching out

The removal of pigment from the surface with a sharp blade to reveal an underlayer or paper. Also an effective way of creating small highlights.

Scumbling

Colours brushed freely over an underpainted area, allowing colour to show through from beneath.

Secondary colours

The result of mixing two primary colours: yellow and blue make the secondary green; red and yellow make the secondary orange; and red and blue make the secondary violet.

Sgraffito

Dried paint scratched off a painted surface with a knife to produce a textured effect.

Shade

A colour that has been darkened.

Size

The gelatinous substance applied to paper and canvas, to protect it from the damaging effects of oil and control its absorbency. Also used as a binder for gesso.

Stretcher

The wooden frame onto which canvas is stretched like the taught skin of a drum.

Support

The surface on which you paint, most commonly for oil and acrylic painters paper, canvas or wooden panels.

Surface

This term refers to the texture of canvas or paper, such as Rough, 'Not' or semi-rough and Hot pressed (smooth finish),

Tertiary colours

Colours that contain all three primaries, created by mixing a primary with its adjacent secondary colour.

Tint

Any colour mixed with white.

Tone

The lightness or darkness of a colour, especially where light falls dramatically on an object.

Toned ground

A coloured opaque layer of uniform tone applied to a primed surface.

Tooth

Describes the roughness of a support's surface texture, or grain, and consequently its capacity to hold paint. Smooth papers have less tooth, so can retain less paint.

Underpainting

Preliminary painting onto which layers of colour can be built.

Unsaturated colour

Mixing a pure, saturated colour with another colour, forms either a tint or shade, and these are unsaturated.

Varnish

Medium used to protect the surface of a completed painting. Available matt or gloss.

Warm colours

Oranges, reds and yellows are described as warm colours, and appear to advance towards the foreground of a picture.

Wet-in-wet

Two wet colours worked into each other on the support.

Wet-on-dry

The application of wet brushwork on a dry surface.

Index

Authors' acknowledgements

Dedicated to the memory of writer and painter Olive Cook (1912–2002). Her encouragement and zest for life made her a wonderful friend – she would have loved this book.

The authors would like to thank the team at Cassell Illustrated, Katie at Essential Works for excellent management and direction, Kate for such a well-balanced book design, and editor, Laurence for fitting everything together so well.

Nick Tidnam wishes to thank Ruth, his wife for all her support throughout this project and Curtis for his continued friendship and collaboration in writing the text.

Curtis Tappenden wishes to thank Susanne, his lovingly supportive wife and manager, his children, Tilly and Noah, and parents, Ken and Pauline for frequent use of the kitchen table! Final thanks to Nick for such inspiring illustrations and committed friendship.

Picture credits

All images featured in the introduction appear courtesy of The Art Archive: p. 7 National Gallery London/Eileen Tweedy, p. 8 Galleria Brera Milan/Album/Joseph Martin, p. 9 (top) Private Collection/Eileen Tweedy, (bottom) Tate Gallery London/Eileen Tweedy and p. 10 Nicolas Sapieha.

Essential Works

Project Editor	Laurence Henderson
Editor/Proof Reader	Angela Gair
Designer	Kate Ward
Indexer	Dorothy Frame